Watercolor
depth&realism

LAURIE **HUMBLE**

NORTH LIGHT BOOKS
CINCINNATI, OHIO
www.artistsnetwork.com

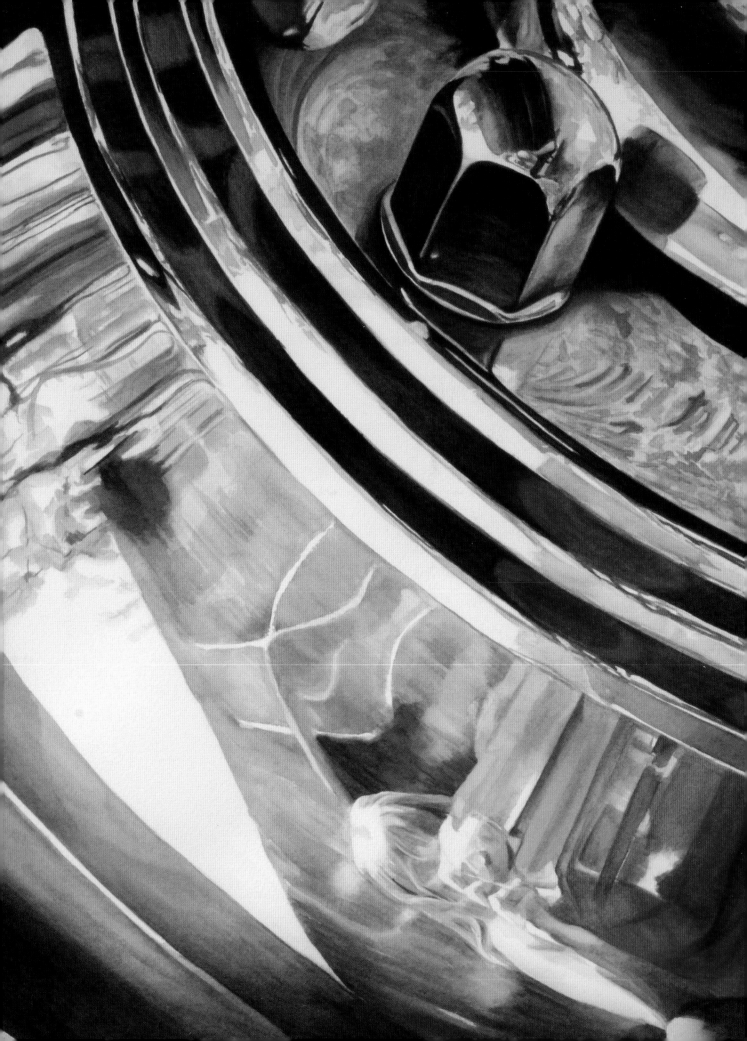

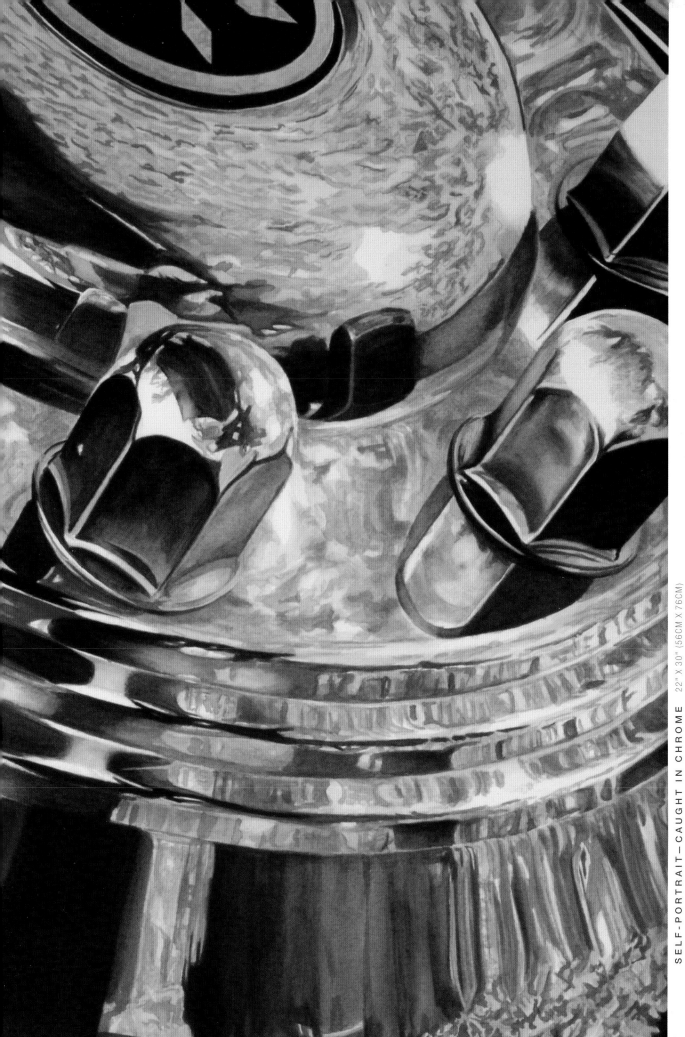

ABOUT THE AUTHOR

After receiving a bachelor of fine arts degree from Texas State University, Laurie Humble worked in many mediums before settling on transparent watercolor. She has concentrated on her love of watercolor and drawing for the past seven years. Her watercolors have appeared in more than fifty national and international exhibitions, including such prestigious shows as those of the American Watercolor Society, the American Artists Professional League, Watercolor USA and the Adirondacks National Exhibition of American Watercolors. Her work has garnered numerous awards.

Laurie is a signature member of the Texas Watercolor Society, the National Society of Artists, Eastern Washington Watercolor Society, Montana Watercolor Society, Georgia Watercolor Society, Missouri Watercolor Society and the Watercolor Society of Alabama. Her work was the subject of a feature article in *American Artist* and has appeared in *Southwest Art* and *International Artist* magazines. Her work is also included in *Splash 10*, a volume in North Light Books' Best of Watercolor series.

Laurie teaches at the Art League of Houston and conducts workshops across the United States. She also teaches live-broadcast Internet workshops with www.artacademylive.com, where she has several instructional DVDs available. Laurie's latest work and current events can be found on her website: www.lauriehumble.com. She lives in Houston, Texas, with her three children.

Watercolor Depth & Realism. Copyright © 2008 by Laurie Humble. Printed in Singapore. All rights reserved. No part of this book may be reproduced in any form or by any electronic or mechanical means including information storage and retrieval systems without permission in writing from the publisher, except by a reviewer who may quote brief passages in a review. Published by North Light Books, an imprint of F+W Media, Inc., 4700 East Galbraith Road, Cincinnati, Ohio, 45236. (800) 289-0963. First Edition.

Other fine North Light Books are available from your local bookstore, art supply store or visit our website at www.fwpublications.com.

12 11 10 09 08 5 4 3 2 1

Distributed in Canada by Fraser Direct
100 Armstrong Avenue
Georgetown, ON, Canada L7G 5S4
Tel: (905) 877-4411

Distributed in the U.K. and Europe by David & Charles
Brunel House, Newton Abbot, Devon, TQ12 4PU, England
Tel: (+44) 1626 323200, Fax: (+44) 1626 323319
Email: postmaster@davidandcharles.co.uk

Distributed in Australia by Capricorn Link
P.O. Box 704, S. Windsor NSW, 2756 Australia
Tel: (02) 4577-3555

Library of Congress Cataloging-in-Publication Data
Humble, Laurie.
 Watercolor depth and realism / Laurie Humble. -- 1st ed.
 p. cm.
 Includes bibliographical references and index.
 ISBN 978-1-60061-045-5 (hardcover : alk. paper)
 1. Watercolor painting--Technique. I. Title.
 ND2420.H85 2008
 751.4'2--dc22
 2008026486

edited by **Stefanie Laufersweiler**
production edited by **Sarah Laichas**
designed by **Jennifer Hoffman**
production coordinated by **Matthew Wagner**
photography by **Joe Gayle**

Metric Conversion Chart

to convert	to	multiply by
Inches	Centimeters	2.54
Centimeters	Inches	0.4
Feet	Centimeters	30.5
Centimeters	Feet	0.03
Yards	Meters	0.9
Meters	Yards	1.1

ACKNOWLEDGMENTS

First and foremost, I would like to thank my brother, without whom this book would not have been possible: professional photographer Joe Gayle, who did all of the photography work. A special thanks to Kristen Flores, who graciously did all the digital imaging work.

I thank Jamie Markle for believing in my idea and giving me the chance, and all the North Light staff for their patience and support during what turned out to be a difficult year for me. A special thanks to my editor, Stefanie Laufersweiler, for calmly guiding me through the entire process. It has been my great pleasure to work with you all.

I also want to thank my parents for their endless love and support: my dad, who was always my best critic, and who helped me to critique every piece in this book; and my mom, Ellen Gayle, who made it possible for me to have the time for this project and was always there to help in any way I needed.

I want to thank my children, Rob, Jamie Lyn and Ben, for allowing me to paint and publish their likenesses time and again, and for being patient and helpful to me while I have followed my dream. I also want to thank my boyfriend, Tom Sawyer, for encouraging me to continue when I was exasperated, and for helping me to find inspiration.

Dedication

In loving memory of my dad, Jerry Gayle, who gave me the greatest gift a parent can give a child. He always made me truly believe that in this life I could accomplish absolutely anything I set my heart on.

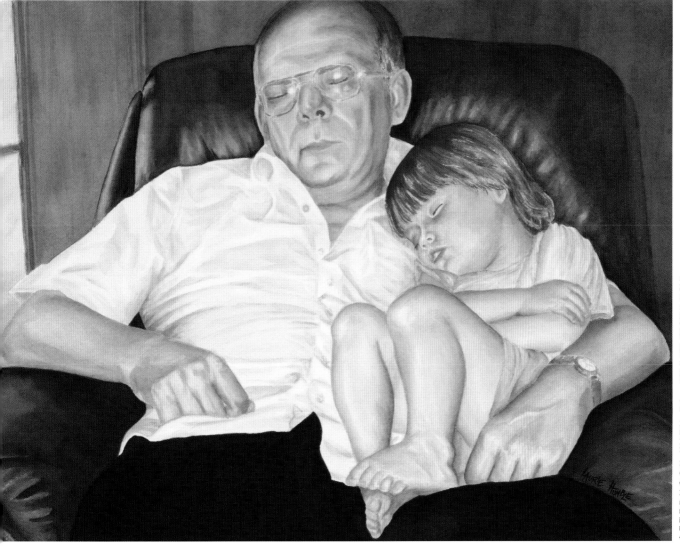

AFTERNOON WITH PA 12" X 16" (30CM X 41CM)

table of contents

1 value contrast 24

Protecting your whites is only half the battle; the magic happens when you get other values dark enough.

2 color saturation 44

Every color in a painting has its place. Place your colors with purpose, and they'll lead the eye wherever you want it to go.

3 perspective 62

The illusion of depth and reality can be shattered if the perspective is off. Learn how to get it right, from every angle.

4 detail 80

Detail is the cornerstone of realism, but areas without detail are equally important to achieve depth in a realistic painting.

5 unifying washes 98

Consider this technique the ace in your back pocket when you need to pull areas of a painting forward or push others back.

6 successfully combining the five techniques 116

Bring all five techniques together to ensure that every painting you make is full of depth—and remarkably realistic.

TOOLS OF HIS TRADE 22" X 30" (56CM X 76CM)

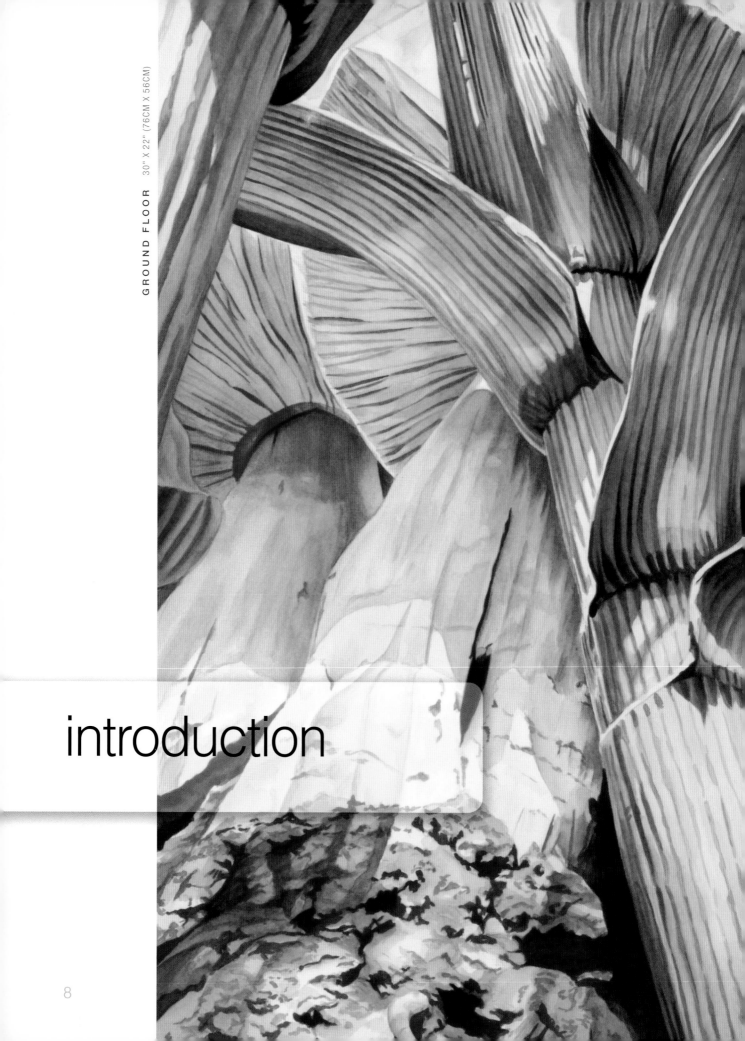

introduction

"The fear of ruining what you have done thus far will keep your work from ever being more than it is at that moment."

I believe that every artist has an innate personal style or inclination, be it toward loose impressionism, ultra-tight realism or something in between. I feel that it is useless to fight that inclination. It is much more advantageous to work on finding ways to improve upon what comes naturally than to try to mimic a style that is not inherently you. My inclination was always toward realism.

Like many artists, I started with oil and acrylic. Watercolor, however, always held a certain mysterious allure. I tried it in college, only managing disappointing, childlike attempts. I gave it up, but returned to try again several times over a fifteen-year period. It wasn't until I gave up my preconceived notion of what watercolor should look like—and the idea that in order to work in watercolor I had no choice but to "loosen up"—that I finally did some work of which I could be proud.

I had read somewhere that the pigments used for oil, pastel, watercolor and other mediums were all the same, that only the binders that held the pigments together were different. This got me thinking that the medium need not dictate a specific painting style or overall look. I had seen plenty of work in other mediums in a wide array of styles, from loose to photorealistic. Why had I thought watercolors must look soft and flowing, when that wasn't really my style? Once I realized that the medium was merely a tool, I finally felt free to create the way I wanted to. This was the artistic epiphany that changed my work.

Ultimately, it wasn't the struggle to try to paint in a specific style that I found most frustrating; looser or tighter didn't seem to matter

that much to me. What had disappointed me most was the lack of depth in my work. I had been painting pale, flat pieces. While my work seemed nice up close, once I stepped back it looked like nothing more than an underpainting you might create to start an oil or acrylic piece. I realized that my work wasn't actually bad, just unfinished. I needed to push it much further and take it to a new level. Over time, with trial and error, I developed a clear understanding of how to do just that.

In this book, I share with you the five techniques I find essential to create a sense of visual depth in a painting: value contrast, color saturation, perspective, detail and unifying washes. While the book is geared toward my love of watercolor and my intrinsic tendency toward realism, all five techniques transcend painting style and medium; they will help you better understand how to give any type of art—even non-objective abstracts—a greater sense of dimension. Throughout the book are demonstration paintings designed to help illustrate the techniques discussed. The initial drawings are shown large enough for you to easily copy them so you can focus on painting along and getting a real feel for each technique.

I've also included several drawing and painting exercises intended to help you find ways to apply these techniques to your own work. At the end of each chapter is a before-and-after comparison of a painting that shows the increase in depth that can result when the method covered in that chapter is employed. It is my great hope that you will find one or more of these techniques to be your artistic epiphany, and that it will help you take your own work to a whole new dimension.

Painting Materials

Brushes

For achieving realism and detail, synthetic brushes that do not hold a lot of water work best. To create a sense of depth, you'll want the paint to stay where you put it, so you can build up meaningful layers of color and tonal value. Natural-hair brushes hold a lot of water, and excess water can cause the shapes you make to flow into areas you didn't intend to paint. Remember, less water equals more control.

Natural-hair brushes tend to be "moppy," losing their shape when wet and resembling a mop more than a brush. Instead, use a brush with "spring": one that readily springs right back to its original shape and maintains a sharp point. A large synthetic brush will hold enough paint and water to cover a large area while also providing a sharp point for handling the finest details. A natural/synthetic blend falls somewhere in the middle.

I find round brushes most useful. I generally paint an entire piece using just one no. 12 or no. 14 round. But, if you feel you can exercise more control with a flat brush or by switching sizes as you paint, then do what works best for you. Occasionally I'll use a 1- or 2-inch (25mm or 51mm) flat or a large hake brush to lay a flat wash in a large area.

I also recommend having a small (no. 2 or so) scrubber on hand: a synthetic brush with very stiff bristles, available as a round or flat (I prefer flat). It can be a great tool for cleaning up errant paint spots and drips, or rough edges.

Brush TLC

Most watercolorists dab the brush on a paper towel to remove excess water after each dip into the water bucket. Rolling your brush and pulling it toward you as you move it across the paper towel will help it maintain its shape and retain its point. Never leave your brushes sitting in water; that is the quickest and the surest way to ruin the point.

Scrubber Steps

- Dip the brush in clean water, just enough to dampen it.
- Dab off any excess water before touching the brush to your painting.
- Gently scrub the paint you wish to remove.
- Use a soft, absorbent paper towel to blot up the paint and any water that remains.
- Use a scrubber for cleanup only when the painting is otherwise finished, as it will slightly mar the paper surface. Any paint applied after a scrubber is used will settle into the scrubbed area and make a dirty-looking mess.

Paper

The paper you use can make all the difference in the look of your finished work. Use professional-quality, 100-percent cotton rag, archival, acid-free watercolor paper.

Consider the surface texture first. Hot-pressed paper is very smooth, but not quite absorbent enough to receive the many layers of paint I use in my work. Rough paper is absorbent but the surface texture does not lend itself to detailed work. I prefer cold-pressed paper, which falls somewhere in between. Surface texture varies by brand even among cold-pressed papers. I look for a cold-pressed paper with the least amount of tooth, or less texture. I want the smoothest surface possible to create fine detail, and also the absorbency to accept many layers of paint.

Also consider the paper's color. Papers are available in many shades of white, from bright white to nearly yellow. I look for papers that are as white as possible, because the paper will provide the white areas in my finished work. The brighter the paper, the more these areas of the painting will appear to glow.

When selecting paper size, realize that you may finish a small piece more quickly, but detail work is much easier to paint when the scale is larger. It can be cost-effective to paint on a sheet that fits a standard-size frame. You can also paint multiple pieces that are the same size—some vertical, some horizontal—so all will fit in a single frame and mat. Then you can switch them out as needed.

I generally use 140-lb. (300gsm) paper and stretch it. Why don't I just use thicker 300-lb. (640gsm) paper and eliminate the need for stretching? Because 300-lb. paper is roughly double the price of 140-lb. The last thing you want to do—especially when you're just starting out—is to make the unpainted sheet dear to you. It is somehow comforting and confidence-building to know it's just paper and can be discarded.

On the other hand, beware of very inexpensive papers. They often have too little or very uneven layers of sizing, a substance added to the paper to make it less absorbent and to help the paint flow evenly. Don't waste your time trying to master techniques on papers that render them nearly impossible.

I attach my paper to a piece of Gator board (which has a foam core and a plasticlike surface). The brand of paper you choose and the amount of sizing on it will determine the best stretching method.

Stretching Paper

- For painting detail and building up layers of color, I prefer a paper with less sizing. It may take some experimentation to find what preparation method works best with your chosen paper and painting style.

- If your paper has a lot of sizing, soak it for three to five minutes in plain water. For paper with less sizing, you may want to simply wet both sides with a large hake brush and clean water.

- Staple the wet paper onto Gator board with the staples 1–2" (3–5cm) apart all around the edges. Don't staple right on the edge; the paper will shrink slightly as it dries and you don't want the paper to pull away completely.

- Let the paper dry overnight before drawing or painting on it. It will wrinkle and buckle at first, but don't worry; it should dry perfectly flat. When you paint on your stretched paper, it may buckle a little, especially if you flood it with a lot of water, but it will dry flat again.

- Leave the paper stapled down until your painting is finished and completely dry. Then, and only then, should you remove your work from the Gator board. Once you remove the paper from the board, it is no longer stretched.

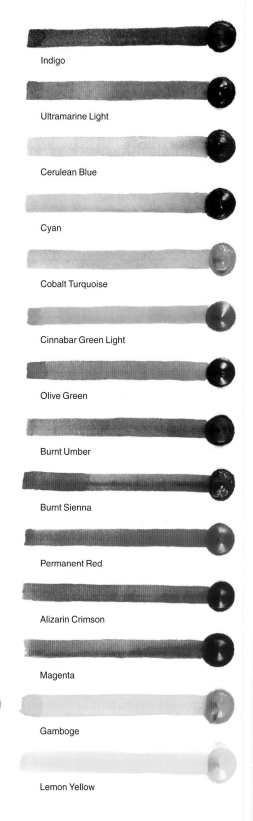

Indigo

Ultramarine Light

Cerulean Blue

Cyan

Cobalt Turquoise

Cinnabar Green Light

Olive Green

Burnt Umber

Burnt Sienna

Permanent Red

Alizarin Crimson

Magenta

Gamboge

Lemon Yellow

These are the main colors I generally use, and the colors we will work with for the demonstrations in this book. I sometimes add or replace colors with new ones that I come across and find interesting. I try to limit the colors I use for any given piece to no more than twelve in order to maintain some color harmony.

Paints

Watercolors come in two grades, *student* and *artist* or *professional*. The main difference is that professional-grade watercolors have a higher pigment-to-binder ratio, making it easier to achieve more vibrant colors. There are many wonderful brands to choose from. Paint is available in pans or tubes. While the pans are convenient for *plein air* (outdoor) painting, tube paints are usually the better choice for studio painting.

The pigments that are used to make paint are either *transparent*, *semitransparent*, *semiopaque* or *opaque*. This is true even of transparent watercolors. Transparent pigments allow light through to bounce off the paper, while opaque pigments block light from getting to the paper beneath. I try to stick mainly to pigments that are transparent because the play of light off the paper itself makes the work appear to glow from within. I do use a few semitransparent pigments, such as Indigo, as darkening agents. These pigments slightly block the light from the paper and help to create greater contrast in the work, which in turn increases depth.

Other Supplies

For my initial drawing I like to use a woodless graphite HB or a regular no. 2 pencil. I find white plastic erasers work best to remove pencil marks (even through one or two layers of dry paint) without marring the surface of the paper. You'll need a plastic or porcelain palette with a large mixing area and enough wells to hold the colors you intend to use. I keep two containers of water handy: one for rinsing my brush, the other for clean water that I use strictly for softening edges. Absorbent paper towels are useful to remove excess water from your brush throughout the painting process. It is always a good idea to have a hair dryer ready to go in case you want to quickly dry a wash.

Dried or Fresh Paint?

Dried paint on your palette takes a certain amount of water to reconstitute it, diluting the color's vibrancy. This works fine for the lighter beginning layers of a painting, when relatively little paint is used. Squeeze out fresh paint when you need to create a darker hue as the painting progresses. Change the paint-to-water ratio to change the value of a color:

More water + less paint = a pale wash

More paint + less water = rich, intense color

For your darkest darks, add only enough water to make the paint flow. You don't want to see brushstrokes.

Collecting References That Work

To avoid any future copyright issues, use your own photos if you plan to show your work. As you select reference photos, look for unusual compositions, different viewpoints, or surprising presentations of everyday scenes. Above all, choose a shot with a clear focal point. A weak focal point—or none at all—will visually flatten your work and give it a "wallpaper" feel, which will make it easy to overlook. Watercolors in particular look best when they incorporate a lot of contrast and long cast shadows. When taking shots you plan to use for reference, try to shoot at mid-morning or late afternoon when the sun is not directly overhead. More than one photo can be used for a single piece; however, this increases the challenge. Take special care to draw all elements in the same perspective and with the same light source or direction of light.

Consider very carefully any photo you plan to use as a reference. You want to make sure that the photo looks "real." Oftentimes the camera catches things at odd angles and distorts images for one reason or another. We tend to accept what we see in a photo without a second thought because we know it is a picture of reality, distortion or no. However, if you paint something in the same distorted fashion, it will not be so readily accepted by the viewer. This is most noticeable with figures and animals. If something doesn't look quite right in your photo, you have a good chance of magnifying the problem in your painting. It is best to simply choose another reference. Once you've found a photo you like that is free of odd-looking distortions, think of changes you can make in your painting that will not only improve the scene visually but give it more meaning. Very rarely will simply trying to copy a photo give you the most realistic or even pleasing result.

FROM PHOTO TO PAINTING

Changes have been made in detail, especially in the shadowed areas. The changes in color, however, are the most obvious. The photo's colors are quite dull; infusing more vibrant color into the painting makes it far more interesting.

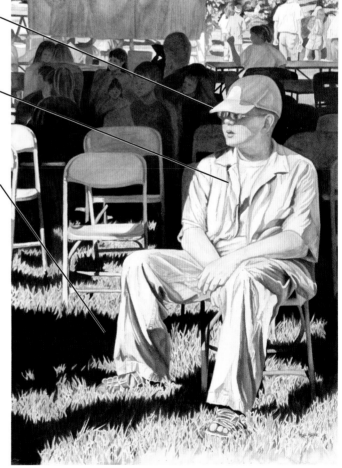

High-contrast areas

The central figure is a clear focal point.

Long cast shadows

SON & SHADOW 30" X 22" (76CM X 56CM)

The Importance of Drawing

A good drawing is the basis for any realistic work. It is particularly essential with watercolor, since whites and light tones need to be preserved. You can do your initial drawing directly on the watercolor paper; however, if you're not highly confident in your drawing skills and anticipate a lot of erasing, you may want to do your drawing on another piece of paper and transfer it. Make sure the pencil you use will erase easily from your brand of paper before you begin.

Projecting your image is another option. Be aware, though, that your image is subject to distortion with this method, especially if you are projecting a reference photo instead of a drawing. Any distortion in your photo will be magnified. A projector should be set up so that the lens is at the exact same angle as your paper, or your image can become oddly elongated. Distortion of this type is especially noticeable on figurative pieces. In short, if you choose to project your image, you should not assume that the drawing that results will be correct. Carefully evaluate it for any perspective problems or distortions before you begin painting.

The process of creating an initial drawing or plan for a watercolor differs from the process used to create other types of drawings. Because of the need to save your whites, you will be painting essentially what is closest to you first and moving back into the scene from there. Always think of your paper as a three-dimensional box with a deep interior, comprising many layers, and keep this in mind as you draw. Draw what is closest to you first, and "underlap" whatever is behind.

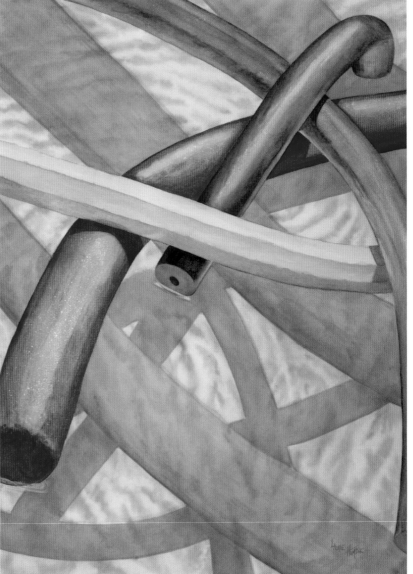

FLOATERS 30" x 22" (76CM x 56CM)

DRAW WHAT IS CLOSEST FIRST

For this painting I drew the uppermost tube first, then underlapped each subsequent tube. Once all four were drawn, I then drew the pool steps and the shadows.

Drawing & Perception

I see drawing as an act of recording your perception of spatial relationships. Five individuals can each render a good drawing of the same subject, yet no two will look alike. We all perceive space differently. This is not to say that I view drawing more as drafting, devoid of feeling or meaning. Rather, I view feeling and meaning as a part of the way each of us perceives the world around us.

DRAW A MINT **FROM THE OUTSIDE IN**

For this drawing exercise, you'll need a round peppermint wrapped in clear cellophane that's twisted closed on the ends. For the best results, read the entire exercise before you begin. Draw it on or transfer it to watercolor paper when finished, with the intent to paint it later. Draw it large enough to fill your paper, touching or going off the edges. The bigger it is, the bigger the delicate highlights will be, thus the easier to draw and paint.

Transferring a Drawing to Watercolor Paper

Graphite paper is a simple option for transferring, but always test it on your brand of watercolor paper before using it to make sure any unwanted marks or smears can be erased. Some graphite papers leave a greasy residue that cannot be removed and is resistant to paint. Covering the back side of your drawing with graphite by scribbling with a pencil that you know will erase will essentially turn your drawing itself into a piece of graphite paper.

1

2

Block In the Large Shapes

Lightly block in the large shapes just to set the placement on the page. Draw what is physically closest to you first. On a close-up object like this, your white spaces are often what is closest to you. I recommend drawing in all the shapes you want to save as white paper. You will be much less likely to accidentally paint over areas you have clearly marked.

Cellophane First

Your first inclination is likely to be to draw and paint the mint and its stripes right off. If you do, you will have already covered up all the highlights necessary to show the cellophane! If you were going to paint in oil, acrylic, pastel or almost any other opaque medium, you could paint the mint first, then cover it with the cellophane. However, with watercolor you must use the mint only as a background necessary to show the clear cellophane. You must paint the cellophane first, then place the mint behind it. The process for watercolor works backwards from that of all other mediums.

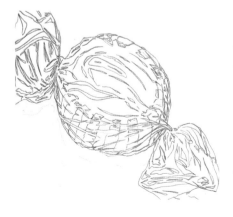

3

Add the Mint Behind

After drawing the wrinkles in the cellophane first, draw the stripes on the mint, which will be broken up by the highlighted areas of the cellophane. Don't allow yourself to get frustrated by the process; it takes a while before thinking in this backward fashion becomes automatic. Once it does, though, you can bring amazing depth to all your work. Save your drawing and try painting it after you have finished reading the book. My finished painting of mints appears on page 116.

Basic Painting Techniques

You want to master three basic washes: the *flat wash*, *one-color gradated wash* and *two-color gradated wash*. The purpose of a flat wash is to cover an area with color evenly. Gradated washes make a smooth transition from color to color, or from dark to light.

Washes turn out best when completed fairly quickly. Try to resist the temptation to go back over any part of your wash that looks a little uneven. You will inevitably make it worse. Introducing water or additional pigment into a drying but not completely dry wash will start the wash moving again, and you run the risk of creating a *backrun* or *bloom* (see next page). Although this can make an interesting and beautiful textural effect when used and placed deliberately, blooms usually occur by accident rather than design. As paint dries, water evaporates and tiny flecks of pigment settle onto the paper surface. Your aim is to have them settle in an even layer. Water added to a wash that is only partially dry will disturb the flecks of pigment, causing them to move away from the newly added water. This is what creates the bloom or backrun.

When you have a mistake or unevenness that you can't live with, it is best to just leave it alone and wait for the wash to dry completely. Once it's dry, you can try to disguise the marred area by applying another slightly darker wash right over it or by blending it into its surroundings.

FLAT WASH
Prepare enough paint to cover the intended area. Elevate the top of your paper slightly so that your paint will naturally run down, helping you make a smoother wash. Using a large round loaded with paint, start at a top corner. Make a long horizontal stroke in one motion across the entire width of the area to be covered. Allow the paint to pool a little along the bottom edge of the stroke. Then paint another long, horizontal stroke, slightly overlapping the first and picking up the "pooled" paint. If more paint is needed on your brush, try to dip only into your initial mixture. Continue until the wash area is completely covered.

ONE-COLOR GRADATED WASH
Begin with the same approach as a flat wash. With each successive stroke, add a little clear water to the paint already in your brush. Ultimately you are striving for a smooth transition from color back to paper.

TWO-COLOR GRADATED WASH
Begin as you would for a flat wash, but prepare two colors. When the paint in your brush needs to be replenished, dip into your second color. You want to make a seamless transition from one color to the other.

Take Control
For maximum control, hold your paintbrush as you would a pencil.

WASH WITH A BLOOM

A bloom is caused by water dropped into an already drying wash. A backrun is similar in look and is usually caused by going back into a wash in an attempt to fix it or by picking up too much excess water along with your paint while trying to complete a wash.

FIXING A MARRED WASH

Let the initial "mistake" wash dry fully. Then go over the entire wash lightly with clean water, paying special attention to the bloom's edges. The bloom occurred because the pigment was disturbed by the introduction of water; it moved out of the center of the area where the water was dropped, and gathered at its edges. You want to move that excess pigment off the harsh edge and back into the area it came from.

REPAIRED WASH

After you have smoothed out the damaged wash as best you can with clean water, again allow it to dry completely. Once it's dry, try to lay another wash of the same color right over the previously blemished one.

DRYBRUSH

This technique is used most often to add texture. Dip your brush in paint, then dab out most of the water on a paper towel. Your brush will skip over the paper's surface, leaving some white behind. The more tooth your paper has, the more dramatic the effect will be. I don't use this technique often because I prefer to paint on a slightly smoother surface, but I occasionally use it over a dried wash for increased texture and depth.

WET-IN-WET

This technique is simply painting on paper which has first been wet or dampened with clean water. If your paper is very wet, you can drop in color and let it flow. You will have very little control over where it goes. It is a fun technique and bears playing with, but it will do little to aid in creating a sense of depth.

WET-ON-DAMP

With this technique, you wet the paper and let the water begin to soak in a bit before painting on it. If your paper is merely damp and you paint on it, you will have a little more control, and your shapes won't run together completely but will have soft, feathery edges. This can be very effective for increasing depth, particularly if used in a background to offset the fine detail within a focal area.

Layering: The Key Technique for Depth

The use of many layers or glazes is an effective way to increase depth in your work. Layers are thin washes of color, applied over previous washes. Since watercolor is a transparent medium, one layer of color can be seen right through the layer of color painted over it.

Always allow a wash to dry completely before painting another layer on top. If your first wash is still wet when you apply a second one, the colors will mix together, giving the appearance of only one wash, and the layered effect will be lost. The color will be affected as well. Two colors painted one over the other while still wet, or mixed together on the palette, look very different from the same two colors layered and allowed to dry between applications. Even complementary colors, which when mixed together generally make brown or "mud," can be layered effectively if allowed to dry.

PLAYING WITH WARMTH 28" X 20" (71CM X 51CM)

PHYSICAL MIXING
Here, Cinnabar Green Light was painted over Permanent Red while the red was still wet. Physical mixing can also occur when colors are combined on the palette before applying them to paper. Depending on the colors used, the result can look muddy and lack depth.

VISUAL MIXING
Here, the red was allowed to dry before the green was layered over it, resulting in clean color. The top color, although always dominant, is transparent enough that the bottom color is visible as well. Depth is created as you look through one layer to the next.

ORDER OF APPLICATION MATTERS
This time the green layer was applied first. As you can see, the results will be different when you change the color used for the final layer.

FROM SOFT BACKGROUND TO SHARP FOREGROUND
Although I usually paint on dry paper, I did paint the background of this piece while the paper was damp to help keep the edges quite soft. Layering and wash techniques were used on the figure, and just a little drybrushing was used to paint the hair.

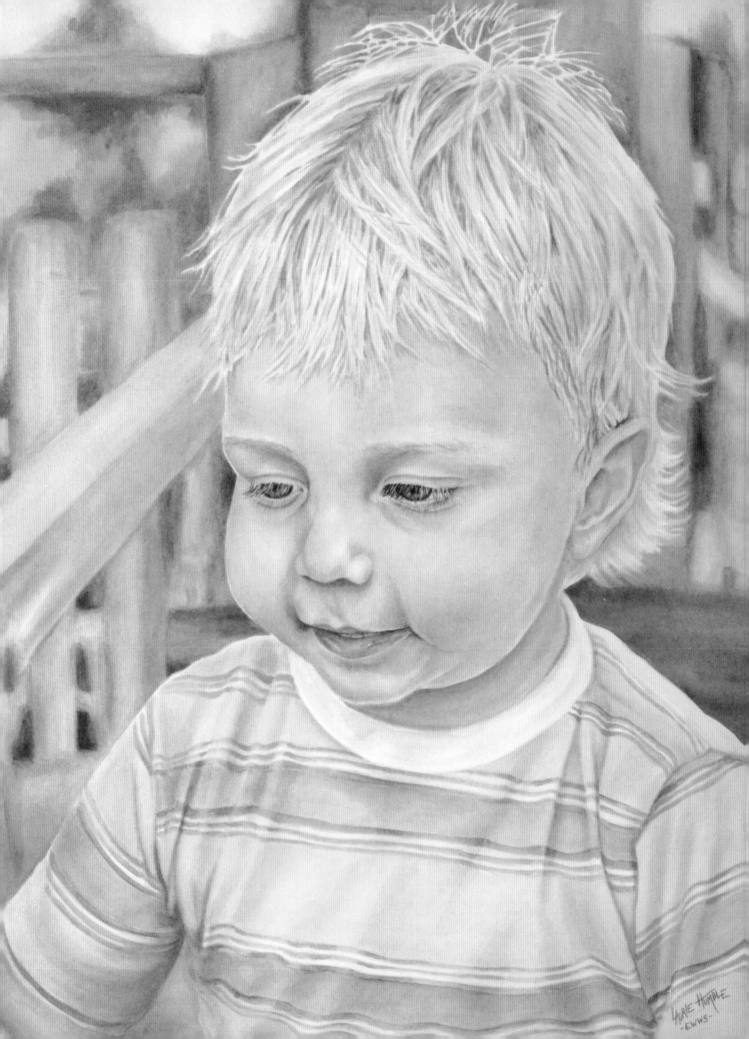

LAYER STARS TO LEARN ABOUT COLOR

Try this exercise to get a feel for how the colors you are using will look when layered. Different effects can be achieved with the same two colors, depending on which color is on top and which is beneath. Adding additional layers with different colors provides even more combinations.

This exercise can be done using only pure color, straight from the tube, or with colors you have mixed on the palette. Ultimately you will want to know instinctively which color to reach for to get the look you desire. Say you have completed a pale underpainting and are not quite happy with some of your color choices; knowing how colors will look when layered together can help you to change the entire look and feel of a piece. Understanding how your colors work together can keep you from making mistakes that could ruin your painting, and give you ideas for saving a painting gone wrong.

COLORS

lemon yellow
magenta
permanent red
cinnabar green light
cobalt turquoise
cyan
more colors of your choice
 from your palette

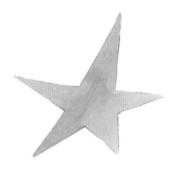

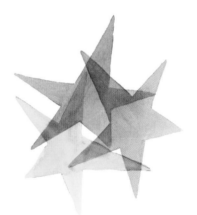

1

Make a Reusable Star Shape

On a scrap piece of watercolor paper, draw a star shape that is at least 3" (8cm) tall, with long points. Cut out your star, place it on a new piece of paper, and trace around it with a pencil. Then set the star aside in a safe place, as you will be using it again and again. Choose a color from your palette (I used Magenta) and mix it with clean water in preparation for a light wash. Mix enough to fill in your drawn star, then paint it, using this opportunity to practice your flat wash technique. Don't worry if your washes are still a bit uneven; the star is a challenging shape for a flat wash, and your main goal here is to grasp the concept of layering multiple colors. Let the wash dry or use a hair dryer before proceeding to the next step.

2

Start Layering

Once it's dry, trace another star, making sure to overlap the first. The star you're tracing should be rotated a little each time you trace to add interest, and to make the most of opportunities to overlap. Paint the second, newly drawn star with Cyan, mixing it only with water. You should notice the color change in the overlapping areas. Continue drawing overlapping stars and painting them with a single-color wash, making sure each wash is completely dry before the next is applied. Paint a third star in Lemon Yellow.

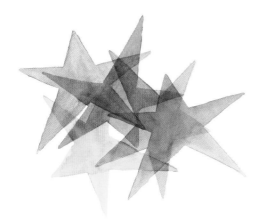

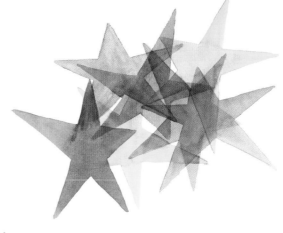

3

Overlap More

Again, the objective is to gain an understanding of how your colors can be used together through a layering process. Try to overlap the points of your star shapes multiple times, layering three or more colors in places. Two more stars were added here, in Cinnabar Green Light and Cobalt Turquoise.

4

Reuse Previous Colors

Paint one more star in Permanent Red, and let it dry. You will want to reuse some of the colors you have already applied so that you can compare how they appear when they are used as the wash on the top layer as opposed to the wash on the bottom layer. Make a Lemon Yellow star that overlaps as many colors as possible.

5

Continue Adding Stars

Bring in some colors from your palette that you have not yet used, and remember to reuse some of the previous colors as well. Try to fill up your paper with the stars, taking them right off the edge of your paper. Leave alone any white spaces between the stars. Label the stars to remind you which colors you used, if you like, and save this exercise, as it makes a nice reference of how your colors look when layered.

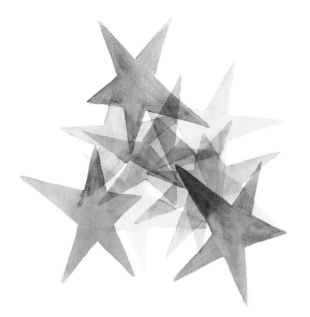

More Stars to Come

When you have finished, set this exercise aside but keep it; we will revisit it later in the book. You might even want to make a second one so you will have one to keep as a color reference and one to experiment with later.

Focal Point: Leading the Way

Composition refers to the arrangement of the elements in a painting. An arrangement that is pleasing to the eye and leads the viewer through the piece is generally considered to be a good composition. You might ask, what exactly does "pleasing to the eye" mean? Certainly this will vary from person to person. In general, a strong, well-placed focal point and overlapping elements that lead the eye through, but not out of, the picture will create a pleasing effect. I'm usually most drawn to works whose elements lead the eye across the surface at an angle.

Every painting needs a clear focal point. It is what draws the viewer into the piece. It is the first place you look

and should be strong enough to keep you there for a while. Anything that you can do to strengthen your focal point will in turn increase the visual depth of the work. The remaining chapters of this book will help to give you some insight into ways to increase the depth of your work while making your focal area ever more prominent.

Design your work in such a way that the viewer will look first at the focal point and then be led by compositional elements through the painting, and back again to the focal point. There are several schools of thought as to how to find the best placement for your focal point, ranging from intuition to using complicated mathematical equations. The rule

of thirds is probably the easiest to use. Simply divide your paper into thirds both vertically and horizontally, using a light pencil line. (This will require only four lines.) Generally, anywhere near any one of the four points where the lines intersect would be a good place for your focal area. Avoid placing your center of interest right in the middle of your piece. Doing so can render your composition static and boring, and make it difficult to lead the viewer through the rest of the work.

You can add a figure to a piece for an instant focal point. It is human nature to seek something recognizable, such as a face or a figure. I liken it to looking at the clouds in the sky and searching for shapes or faces.

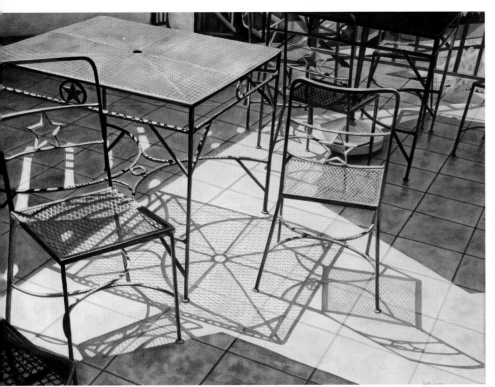

PATIO PATTERNS 22" X 30" (56CM X 76CM)

SHOWSTOPPER SHADOWS

The many elements in this painting are not what draws the eye; the shadows are the focal point here. This composition is pleasing because its elements lead the eye throughout the piece and keep it there. Interesting perspective, angles and patterns of light also make this piece appealing.

So, What Do You Think?

Avoid asking people if they like your work; instead ask if there is anything about the piece that bothers them. You're much more likely to get an honest answer and a helpful point of view.

before&after

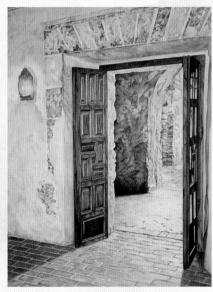

BEFORE

The original doorway created a focal point, but there wasn't much to focus on once you got there.

Add a figure for an instant focal point.

The ghost monk strengthens the focal point and gives more meaning to the piece, which is set in an old mission with bits of its original frescos still visible.

The shadows were darkened with combinations of Cyan and Indigo. The original was slightly warm in tone; the added ghost dictated a cooler feel.

Adding more cool blues with unifying washes tied together the texture on the wall and pushed back the doorway, creating more depth.

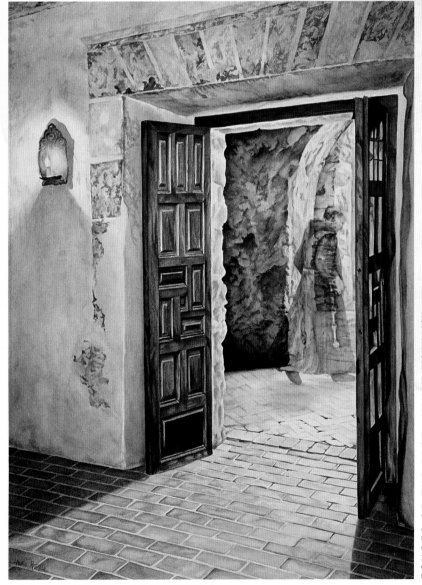

AFTER

ECHOES OF THE PAST 30" X 22" (76CM X 56CM)

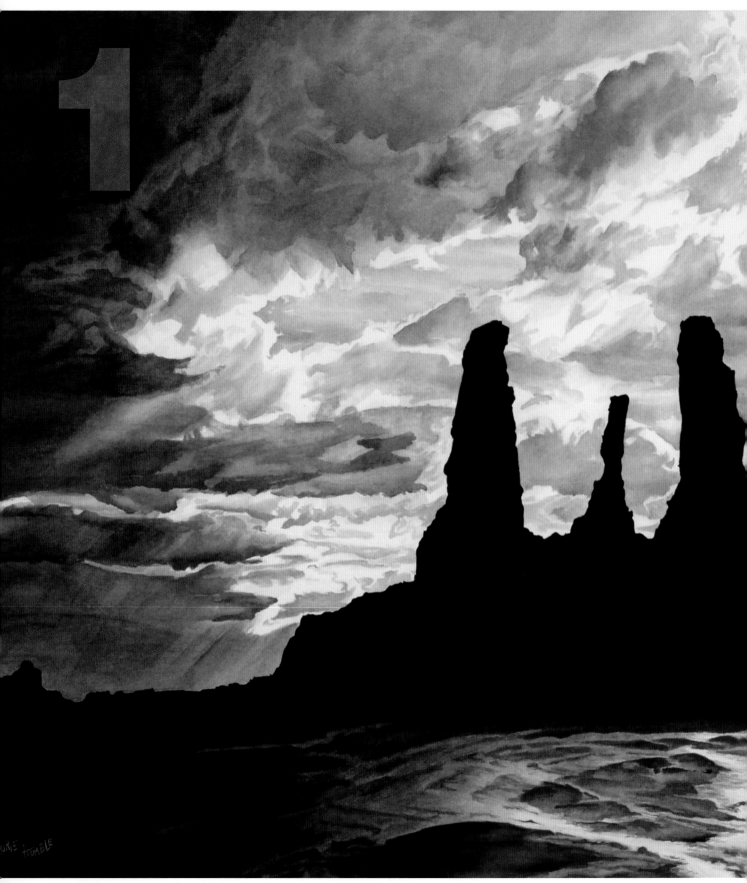

AFTER THE RAIN 20" X 30" (51CM X 76CM) COLLECTION OF ELLEN GAYLE

value contrast

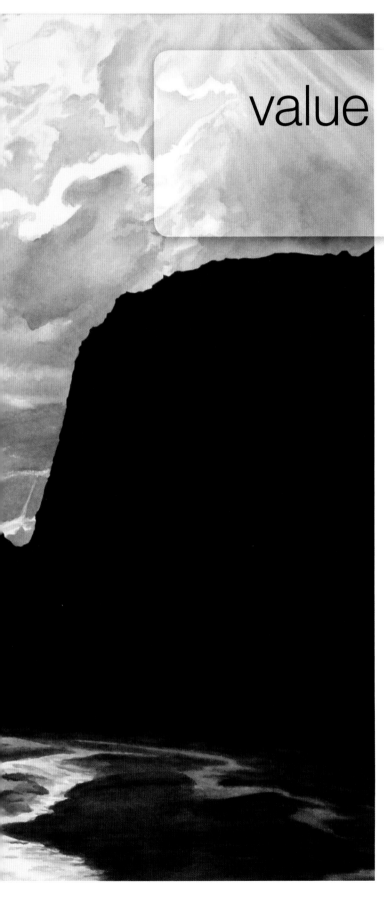

Most watercolors tend to look as though they have contrast and rich darks when viewed up close, but from just a few steps away, they may seem pale or faded. Rarely can a piece with little contrast draw the eye of the viewer. Your painting should look just as good from a distance as it does when it's right in front of your nose. High *value contrast* will draw the eye to a painting, no matter what the medium. High contrast refers to the difference between the lightest light and the darkest dark. The greater the difference, the higher the contrast. Contrast can play a huge role in the amount of depth you are able to achieve. In every painting you want to create as full a range of values as you can, from brilliant white to near black.

THE UNMATCHED GLOW OF SAVED WHITES

Extreme contrast was used in this piece to make the sky appear to glow with light. Leaving the white of the paper was important because light bounces off the paper itself and appears brighter than a white paint ever could. The glow of light reflected in the water in the foreground helps to move the eye throughout the painting.

How Medium Affects Contrast

Watercolors are generally applied from light to dark. Start with very pale layers to establish your lightest values first, leaving unpainted paper as your white areas. Slowly building upon your initial layers, you can create your midtone areas with more transparent layers. Add dark tones and darkest darks last. With this approach, your painting starts out looking like a pale underpainting and gradually begins to deepen into a piece with a more three-dimensional feel.

In traditional watercolor painting, white areas are nothing more than the unpainted paper. Because watercolor is a transparent medium, it also utilizes the white of the paper itself to help create lighter areas. With mediums such as oil or acrylic, white and black are added to colors to lighten or darken their values.

With watercolor, however, you generally don't add white or black. Most white and black tube watercolors are opaque, which can dull the overall look of a transparent watercolor painting. Opaque watercolors block light from the paper and the colors tend to dry flatter, which keeps you from achieving the kind of depth possible with transparent layers.

It is more effective to create different tonal values just by increasing or decreasing the amount of water added to the paint. When the paper is allowed to show through many thin veils of color, light bounces off the paper surface to the eye, creating a glow. The piece appears to be lit from within. This glow helps to increase the contrast, which in turn increases depth.

Save White Paint for Last

Most white watercolors are really *gouache*, which is a completely different medium. Gouache is an opaque, water-soluble paint that cannot be layered over without reconstituting the white layer. Consequently, it is best to save any use of white paint for finishing touches, such as tiny highlights that have gotten lost.

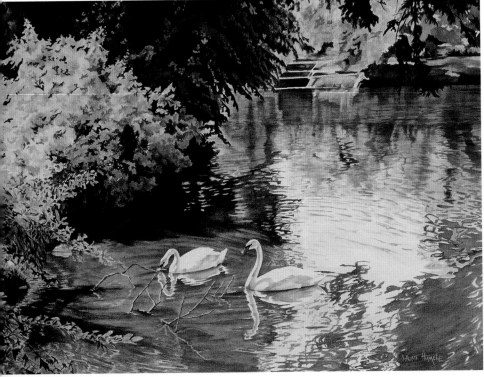

TWO SWANS A SWIMMIN' 20" X 37" (51CM X 94CM) COLLECTION OF CHARLES H. HILL III

HOW OPAQUE DARKS BRING OUT A SUBJECT'S GLOW

The buildup of very dark layers gives a more opaque feeling to the water directly around the swans. It is this considerable contrast that makes the swans seem to almost glow from within and become a very strong focal point.

The Importance of Saving Whites

The ability to maintain your white and light areas is crucial to creating high value contrast and achieving a sense of depth. Once lost, whites are very difficult—if not impossible—to reclaim. You can use white paint to add highlights; however, being opaque, it goes on thicker and dries with a slightly blue or gray cast to it. It does not have the same look as that which you can achieve if you use the white of the paper. It is for this reason that saving your whites to begin with is preferable to trying to add them in the final stages of a painting.

To save whites, you have two choices: mask them off, or paint carefully around them.

Masking

If you are going to use a masking agent, masking fluid is probably the best choice for watercolor. Once dry after application, masking acts as a resist to paint and water. The advantage of using masking is that you can paint a wash right over an entire area without fear of permanently losing your whites.

After you have finished painting the areas surrounding the masking, and when your paper is completely dry, the masking can be removed. Then you can evaluate your painting to see what changes you want to make. Use of masking fluid will leave you with shapes that have hard edges and bright whites. You may need to soften some edges and tone down some of the whites for a more natural look, no matter what the subject is. The last thing you want is for your painting to scream, "This is where I put the masking fluid!"

Masking is most beneficial when you want to create a large flat wash or if you have just a few highlights in a wash area. You can even mask over an already painted and totally dry area so that you can put color into a background area. A masking pen (available at most art supply stores) can be a useful tool. It creates a very fine, even line of masking fluid perfect for saving the small delicate whites you might have when painting hair or grass. I'll occasionally use a masking pen to sign a painting when I want the signature to appear in an area that is going to be very dark.

Painting Around

I very rarely use masking fluid, as I find it to be more trouble than it is worth. I find it easier, more effective and, in the long run, less time-consuming to just paint around my whites.

When you choose to paint around your whites instead of masking, you can easily maintain details and soften edges as you go. Using this method, though, means that a good initial drawing is essential. The more decisions you make in the drawing phase, the easier it will be to create a feel of realism.

A drawing done for a watercolor painting differs slightly from other types of drawings. The main purpose of your initial drawing is to remind you of where you want your white and lighter areas to be. You want to approach your drawing more as a series of shapes rather than lines. Remember to think in terms of layers of depth, even when working on your drawing. Think about underlapping. Which elements are behind other elements, and how far back in the picture plane should they be?

Once you are satisfied with your drawing, start by painting your very lightest tones, using mostly water and very little paint. It is a good idea to block in the entire piece very lightly. Create a pale underpainting that you can darken gradually. The underpainting will also serve as a map for the finished piece.

Color choices can be evaluated and color and value changes can be made during the darkening process. Slowly and carefully build up your dark tones, always leaving some of the areas of the previous layer visible. As you add layers and darken, always vary the shapes you paint. In other words, never just darken a previously painted shape. You want to make a new and different shape with each new layer. Never completely cover up your previous layers; the idea is to build up many different values.

How to Regain White

To reclaim an accidentally painted-over white, try lightening it with clean water and dabbing with a paper towel. When the area is completely dry, darken the values around the area to make it appear lighter.

USING MASKING FLUID FOR A POND SCENE

Experiment with masking fluid to see if you like working with it. Some people think it is fun to use and love the results they can get. Others, myself included, just don't care for it. As in all aspects of art, there is no right or wrong here, only what works best for you. Try this demo to see if masking fluid is for you. You will need masking fluid (also called *liquid frisket*) to complete it.

COLORS

gamboge
magenta
cyan

Indicate Areas of Masking as You Draw

Create a simple line drawing, making sure to indicate areas you plan to mask off.

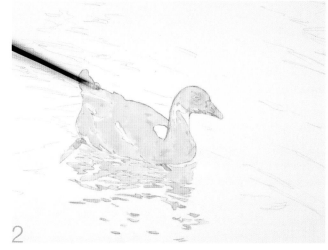

Apply Masking Fluid

Using the handle of a small paintbrush, apply masking fluid to all the areas that you want to keep pure white. If the fluid starts to dry on the brush handle and gum up, simply wipe it clean with a paper towel. If left to dry on the brush handle, it will lift off fluid you've already applied and make it very difficult to apply more.

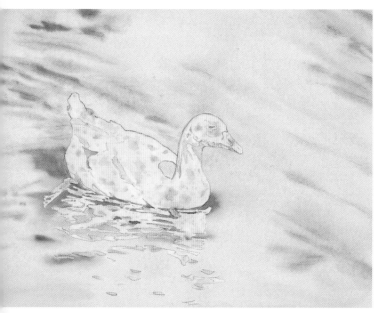

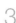

Paint Over the Dried Masking

Wait until all the fluid is completely dry before applying any paint. Dry masking may still feel slightly tacky to the touch; this is fine. Impatience here will cause you to smear still-damp fluid and possibly ruin a good watercolor brush. Paint a light wash of Cyan over the entire paper. Add Cyan to areas you want to be darker: the ripples in the water and around the base of the duck.

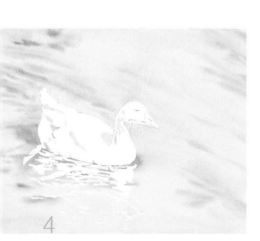

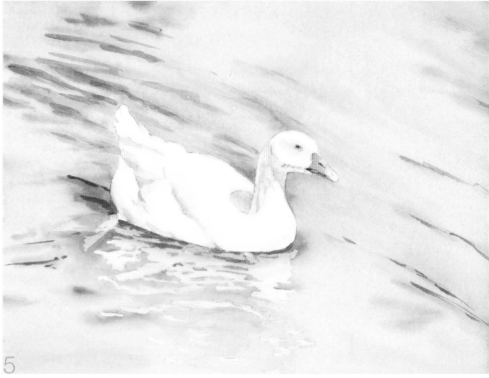

4
Remove the Masking

Once the painted paper is completely dry, remove the masking fluid. If you try to remove it before the paper is dry, you run the risk of marring the surface of the paper.

5
Finish Painting

Finish the duck by adding some midtones and darks. Gamboge can be added to the beak and feet. Bring a few pale touches of Gamboge into the water and the shadow areas of the duck's feathers. Add some Magenta to the shadows as well. This example could be taken even further with additional layers to increase the contrast. As you add darks, make sure that you don't inadvertently paint over the midtones or the whites you saved initially.

Masking Fluid Tips

- Mix your jar of fluid well before using, as it tends to separate. Don't shake it, though; any resulting bubbles that are then applied to your paper tend to pop once the fluid dries, leaving tiny unmasked dots which will then accept color.

- The tip of a narrow paintbrush handle makes a good tool for applying masking fluid. Any dried fluid wipes easily off the paint-coated surface of the brush handle.

- It is possible to make a somewhat softer edge with masking fluid by dropping it onto damp paper. The fluid will mix slightly with the water and the edges will bleed a little, creating a more feathery edge.

- Make sure your paper is fully dry before removing masking fluid. Once you've painted a wash over the dried masking, it will take the paper longer than usual to dry. Removing the masking while the paper is still damp can damage or tear the paper surface. Remember, if your paper feels slightly cool to the touch, it is still damp.

- Be mindful of how long you leave masking fluid on your paper; I wouldn't recommend longer than a week. Left for long periods, it can become less pliable and more difficult (sometimes impossible) to remove. I have also seen the tint which is added to some masking fluids actually dye the paper when left on too long.

PAINTING AROUND THE WHITES OF A FACE

This demo provides a great opportunity for you to practice the technique of saving your whites by carefully painting around them. I have chosen to use a face because you need surprisingly little paint to create a realistic skin tone. The face also provides a great many white and light areas to work with.

COLORS

gamboge
alizarin crimson
burnt sienna
burnt umber
cerulean blue
ultramarine light
indigo

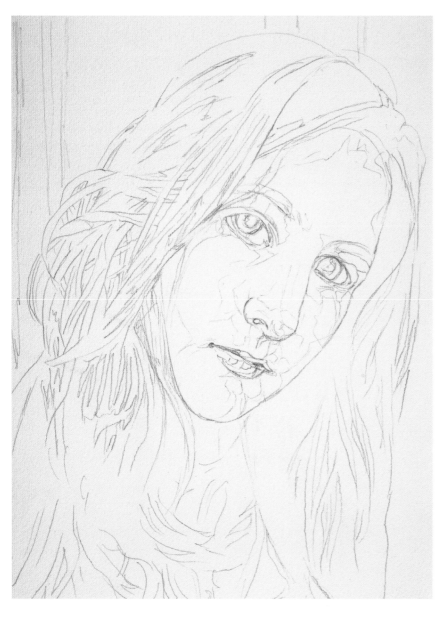

1

Make a Careful Line Drawing

Include as many shapes as you can. The shapes should indicate which areas you want to remain white, as well as your darker areas. It is not necessary to draw every shape you intend to paint, especially your midtones. Too many shapes can cause you to get lost in your drawing when you attempt to paint. Create a map for your painting showing where your whites need to be so you can apply paint around these areas, not in them.

2

Protect Your Whites by Painting Around Them

Mix Alizarin Crimson and Gamboge for a pale peach or fleshlike hue. Using mostly water with a hint of the paint mixture, apply to all the areas directly around the areas you want to keep white. This makes your white areas more readily visible, so you will be less likely to accidentally paint over them. It is important to leave some strands of hair along the hairline unpainted. This will help to break up lines around the face and keep the hair from looking like a wig.

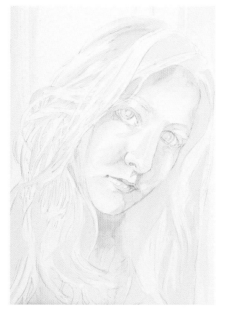

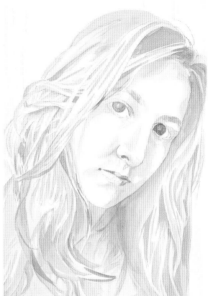

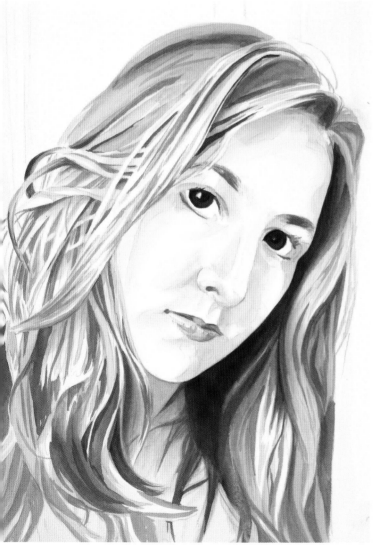

3

Add Midtones Without Obscuring the First Layer

Begin to add midtones by gradually darkening with layers of the same color used in step 2; this time, however, use more paint and less water. Make sure that you leave some of the first layer of paint untouched. The plan is to create as many tonal values as possible to increase the depth of the piece. If you continually paint entirely over the previous layers without leaving some of each layer visible, you will end up with only two values, light and dark.

4

Begin Building Some of the Darker Values

Burnt Sienna and a touch of Ultramarine Light can be added to deepen values. Add Burnt Umber to the eyes, brows and the shadowed areas of the hair. Mix Burnt Umber and Indigo to make a rich dark for the pupil of the eye and for lashes. No matter how many eyelashes you see, paint only a suggestion of them. Just a few wispy lashes in the outer corners of the top lids, and just the faintest hint on the outer corner of the bottom lids, are all you need. If you paint too many lashes, or if you paint them all exactly the same size, shape and distance apart, they will look unnatural—or worse, like spider legs. Add a wash of pure Alizarin Crimson to the lips, avoiding saved whites. Bring a little of the flesh color into the background; this will help the background and the figure to relate to each other.

5

Bring the Portrait to Life With Color

Paint a pale Cerulean Blue wash into the corners of the whites of the eyes and just beneath the top lid, to make the eyeball look round. The Cerulean Blue should be integrated into the piece in other places as well, such as shadow areas in the hair. When you add it to the background, it will help show off the figure. Mix a touch of Alizarin Crimson with Gamboge for a yellowish flesh tone. Use this mixture to wash over any shadowed areas of the skin, especially the deeply shadowed side of the face and the neck; this brightens the face, increases realism and adds depth. Be sure you don't lose your saved whites by continuing to paint around them.

Mix some Ultramarine Light with Alizarin Crimson for a light violet shade; use it for the darkest shadows on the face and neck, being careful not to go too dark too fast. Paint some shadows on the nose and along the sides of the forehead to give the head a more three-dimensional feel. Using Ultramarine Light and Alizarin Crimson in separate layers, add more color and more darks to the lips, still painting around saved whites. Using mixtures of Burnt Umber and Indigo, deepen the values in the eyes and the lashes. Remember never to paint over the previous layers completely; rather, paint new, smaller shapes with each successive layer.

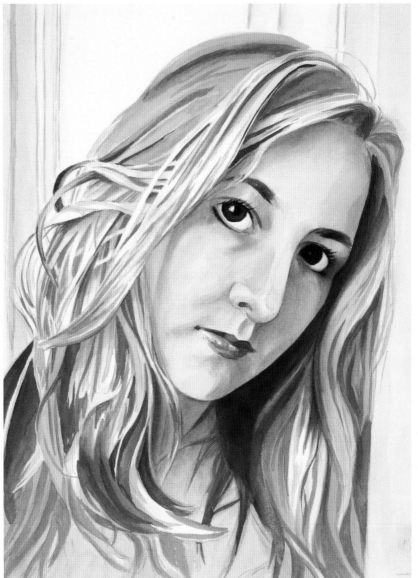

JAMIE 15" X 11" (38CM X 28CM)

Erase Last

I usually erase any errant pencil lines once the painting is finished and completely dry. Going over the piece with a clean white plastic eraser also removes any graphite dust that may have mixed with your paint during the painting process. The result is clean, fresh color.

6

Add Rich Darks for Increased Contrast

Add Burnt Sienna to the same violet you mixed for step 5, and use this combination for the darkest darks in the skin. Use this on the neck, the cast shadows near the eyes, and, most of all, on the shadowed side of the face, near the eye and nose. With mixtures of Burnt Sienna, Burnt Umber and Indigo, paint layers of darks in the hair. Place darks carefully to show deeper areas in the hair, always leaving some whites and previously painted areas alone. This usually takes several passes to build up multiple layers of values.

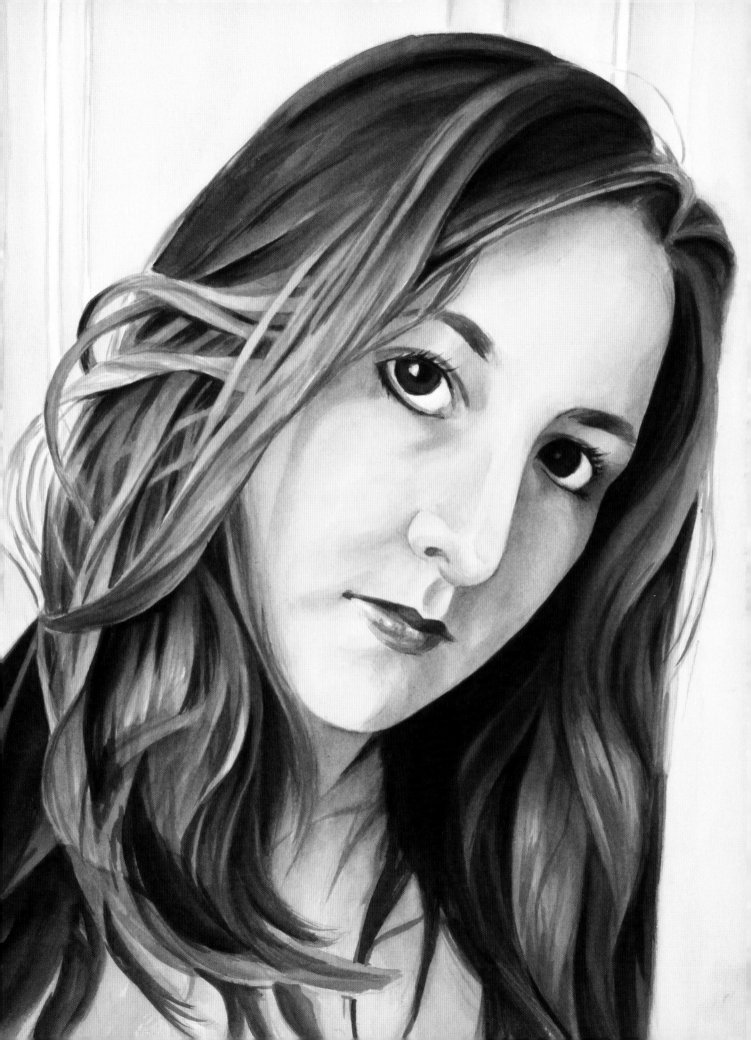

Getting Your Values Dark Enough

Value contrast is extremely important when several items in a piece are similar in color. Light and dark values of even the same color can be played off each other to create depth by making some areas appear more important than others. Lack of value contrast will make your work seem flat. It is not enough to use many different colors, if they are all similar in value. For example, a midtone blue painted next to a midtone red might look contrasting enough up close, but from afar, while you will see the color difference, there will still be no sense of dimension unless one of the colors is at least slightly darker in value.

It is sometimes difficult to decide if you have achieved enough value contrast, if you have made your darks dark enough. If you are not certain, then usually the answer is no, you haven't taken the painting far enough. I see far more paintings that appear unfinished to my eye than I see paintings that I would consider overworked.

One way to tell whether you have achieved a high level of contrast is to hold something black next to your darkest dark. If your darkest dark is lighter in tone than the black object, you know you can still go darker, further increasing the contrast and thus the depth.

Remember that when you want to really build dark tones, use fresh paint. You may even need to employ an almost dry-brush technique to apply fresh paint on top of your darks to get them dark enough. Your darks may take on a chalky appearance up close. This is just the result of pigment sitting on the paper surface, no longer sinking into the already-saturated paper. At this point, be careful not to drop any water onto your dark areas, as the pigment that is sitting on the surface will move.

Above all, remember that the greater the number of different values you can produce, the greater the depth of the finished piece will be.

Revisit the Star Exercise

Now you can build on the star exercise you saved from the introductory section. Once your paper is filled with stars, paint the spaces in between very dark. I used Indigo here. You are creating strong contrast. See how bright the pale stars appear now that they are on a dark background?

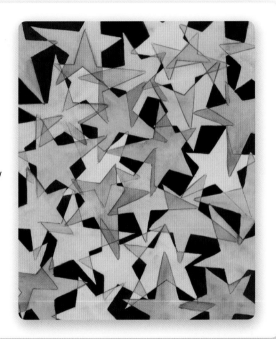

EXPLORING VALUE RANGE

It can be hard to process the idea of values when working in color. Almost any color can have the same wide range of values as gray. Make a value scale with each color on your palette. Start with the lightest values you can make using mostly water and a bit of color, then gradually increase the paint and decrease the water.

Put a gray scale next to your work. Notice whether you have incorporated light colors of a similar value to the lighter grays, and darks that are close to the blacks on the gray scale.

HOW VALUE RANGE AFFECTS VISUAL DEPTH

The first sketch has only three or four different values, not a wide range from very light to very dark. The painting more closely resembles the second sketch, with colors that range from very light in value to almost black. The results are much more dynamic and give a greater sense of dimension.

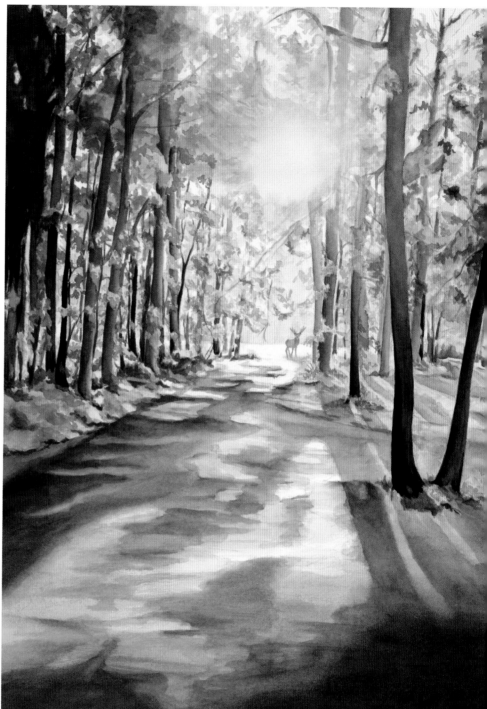

OH, DEER 20" X 14" (51CM X 36CM)

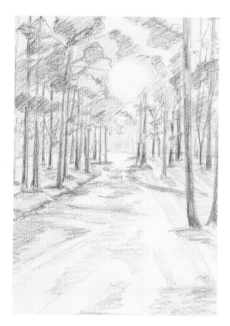

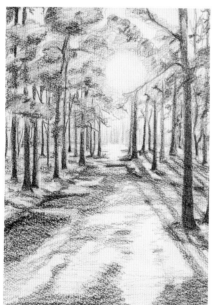

Don't Get Carried Away

Beware of falling into the trap of thinking: "If it works in this spot, it's going to work everywhere." You don't want to darken everything and end up with only three values: white, light and dark. That will make your work look flat.

When to Decrease Contrast

While you want to create high value contrast, you also want to save your area of highest contrast for your focal area. The area where your lightest light meets your darkest dark will immediately draw the eye. If you have multiple areas in a painting where this occurs, they will compete for the viewer's attention. Too many areas of equal interest flatten the overall look of a piece; in essence, it will be boring no matter how much work you put into it. To create a great sense of depth and a strong and inviting painting, establish one clear focal point. Secondary points of interest are fine—great, even—as long as one stands out above the rest.

To make your focal point stronger, you may need to tone down the contrast a little in competing areas. Using a color that is predominant in the background, lay a pale wash over any bright whites in less important areas. This will make them less prominent and make the brightest whites in your focal area appear even stronger. If any part of your background seems too dark, you can try to lessen the effect by washing lightly over the area with clean water. Fade the darks gradually into the lighter areas. A smoother transition from dark to light will help to decrease the contrast in any areas of secondary importance.

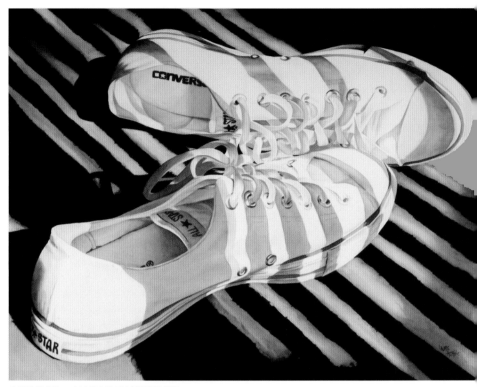

CHUCKS 22" X 30" (56CM X 76CM)

WASHING OVER WHITE

When painting white objects, leave a lot of paper unpainted at the start. Eventually you'll need to add pale washes of color to tone down and push some areas back. Multiple whites against a dark background will compete for the viewer's attention, and you will have to decide which areas to leave alone and which to wash over. Here, there are surprisingly few areas of plain white paper, because many pale washes of color were used to add dimension. The focal point is not the lightest because the shoes appear to be all white. In this case, although high contrast is used, the focal point is strengthened with the use of saturated color, which you'll learn more about in chapter 2.

Make Your Shadows Lively

While you want to play up the contrast, avoid making all the shadow areas too dark. Never paint all the shadows in a piece a flat gray or black. Shadows, while being darker areas, should still reflect some of the color of the object that is casting them. Playing up that color adds interest to the work. Also remember that shadows are always darker closest to the object that casts them, and start to fade away as they get farther away from the object.

HIGH VALUE CONTRAST: BOARDWALK SCENE

You will create a high level of value contrast in this demonstration. You will use the points where your lightest lights meet your darkest darks to strengthen your focal area. This is an opportunity to practice building rich darks while saving white spaces and light areas. As you work, try to make smooth transitions from your midtones to your darks by softening edges as you go. You may want to try using a dry-brush technique for the final darkening phase in areas you want very dark, where any addition of water could damage what you have already painted. Your goal is to create interest throughout the painting but to keep the focus on the main figure.

COLORS

lemon yellow
alizarin crimson
permanent red
burnt sienna
burnt umber
olive green
cinnabar green light
cyan
ultramarine light
indigo

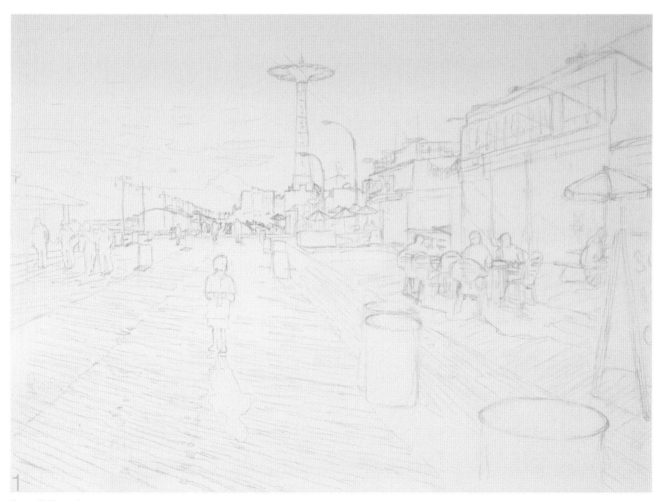

Pencil Drawing

Begin with a light pencil drawing, paying special attention to creating shapes you want to keep white or light. Draw in some of your darks as well. When working with figures and perspective—which we'll delve into further in chapter 3—try to establish correct proportions *before* you begin to paint. Now, while erasing is an option, is the time to make corrections.

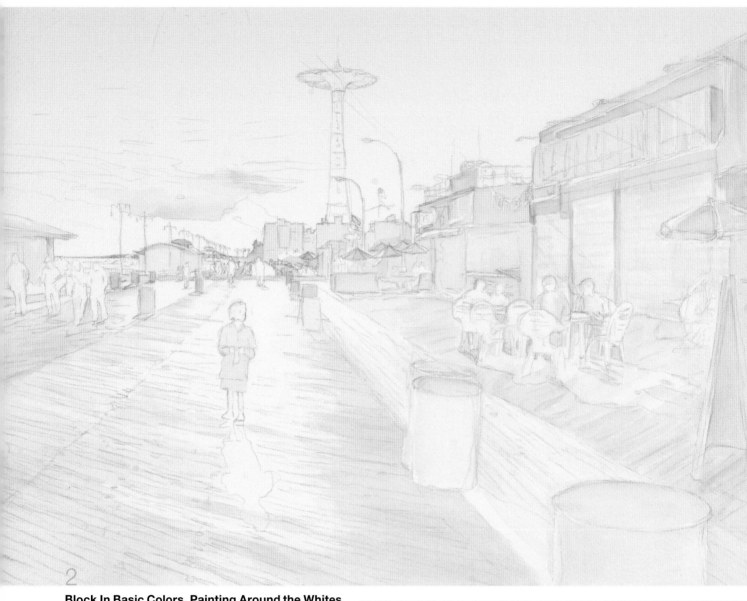

2

Block In Basic Colors, Painting Around the Whites

Use Ultramarine Light on the dark sides of the buildings and the cans. Paint the darkest cloud and the distant ridge across the water. Still using the Ultramarine Light, paint some of the darker boardwalk boards and put some color on the main figure. The sun is setting, so use Lemon Yellow to suggest a glow of fading sunlight on the buildings and the darker side of the boardwalk. The yellow will replace bright white in the darkest areas. Mix a little Cinnabar Green Light with Olive Green and paint the buildings, roofs, a few umbrellas and the tiny bit of foliage. Add a pale layer of Alizarin Crimson to the buildings, roofs, some of the umbrellas and the boardwalk areas nearest to where the light is hitting the ground.

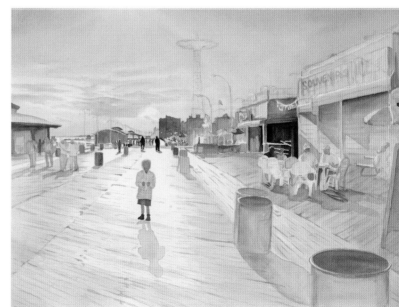

3 Lay In a Smooth Sky and Add Some Darks

Dampen the entire sky area with water. Using a flat wash brush, paint a pale layer of Cyan onto the damp paper, leaving an area of white to suggest the setting sun. Using a damp round brush, quickly lift paint out of any cloud areas you want to remain white. Dry the sky with a hair dryer to avoid blooming. Once this is dry, use Ultramarine Light to add a few darks to the clouds, softening edges as you go. Darken the cans and add a few details to the main figure and the seated figures. Deepen the ground on the right with Burnt Sienna. Darken the buildings with the same green you mixed in step 2. Suggest beachgoers in the distance with a touch of Burnt Umber. Add a touch of Alizarin Crimson to a few of the distant figures and umbrellas. Use some Permanent Red on the foreground umbrella and the vendor stand in the distance.

4 Increase the Color

Dampen the sky with water again. Use Cyan to darken the sky at the corners of the paper. With Ultramarine Light, suggest a darker underside on the clouds. Paint the buildings on the left with a mixture of Burnt Sienna and Ultramarine Light. Use Burnt Sienna to paint the flesh on the main figure and those seated. Paint the shadowed areas of the buildings with mixtures of Indigo and Ultramarine Light. Add color to the distant buildings with various blue shades for added interest. You want color in the distance, but keep it fairly pale and use soft edges for atmospheric perspective. Add a few Alizarin Crimson details to the umbrellas and flags. Use the same color to indicate some lettering on the signs. Darken the cans and foreground sign with washes of Indigo.

5

Imply the Sunset's Glow

To support the setting sun, add some Alizarin Crimson to the undersides of the clouds. Paint the edges of the figures on the left, as well as the main figure, with Alizarin Crimson. This will help them glow when you add darks in subsequent steps. Imply little figures in the background using mixtures of Indigo and Burnt Umber. Vary the values from figure to figure for a more realistic look. The darkest figures should be the ones with the sun setting directly behind them. Other figures might have some light illuminating them from the side. Paint shadows cast by the figures, cans and signs with Burnt Sienna. Use Burnt Umber to darken the shoes on the main figure. Darken the buildings on the left with Burnt Sienna and Ultramarine Light. Use the same mixture to indicate the shadows under the tables on the right. Add Indigo darks to the buildings on the right. Use Ultramarine Light and Burnt Sienna to put a bit of detail on the table, chairs and seated figures.

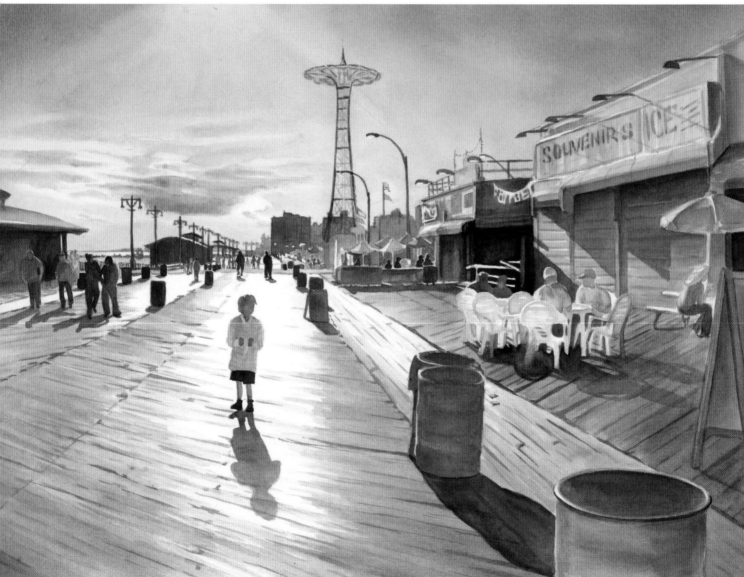

6

FInish the Sky

To evoke the feeling of dusk, darken the sky a bit more. Again, dampen the area with water. This time, use Ultramarine Light to really darken the corners of the sky, being careful to make a smooth transition from darker to lighter blue. Dry the sky, then finish it by adding more darks to the undersides of the clouds with Ultramarine Light. Try to maintain soft edges in the clouds so that they will recede into the background; you want to see them but not call too much attention to them. Put a wash of Ultramarine Light over the buildings and figures on the left. Using Ultramarine Light, begin to refine the seated figures, the cans and the sign on the right. Enhance the background area under the umbrellas with a few touches of Ultramarine Light and Olive Green.

7

Details, Details

Mix Indigo and Burnt Umber to make a warm black. Carefully paint the light poles using the tip of a larger round (no. 10, 12 or 14). The poles should gradually become lighter in value as they recede into the distance. Paint the tower with the mixed black. Use lighter values for the details and darker values for the main beams in the structure. Add Ultramarine Light to the shadows cast by the figures. Remember that shadows are darkest next to the object that casts them, and fade away from there. Begin to darken the boardwalk with layers of Burnt Sienna. You will want to retain the light areas, so bring color in gradually, suggesting wooden boards. Don't paint every board; merely impart the feeling of wood.

8

For Dusk, Darken Select Areas

You may want to read chapter 5 on unifying washes before doing the next two steps. Lay a final wash of Indigo over all the cast shadows. Deepen the colors on the buildings and the umbrellas. Using Indigo, darken the figures to the left, with the sun more toward their backs. Darken the building behind the other two figures to bring them out more. Darken and tone down the distant buildings with a light wash of Indigo.

Working now on the right side of the piece, use Ultramarine Light and Indigo to darken the cans, the shadows on the buildings, and the sign. Add a bit more detail to the chairs by darkening those farthest back. Once this is completely dry, lay a light wash of Ultramarine Light over the entire table and chair areas to tone down the white and make these areas less prominent. Mix Permanent Red and Burnt Sienna to deepen the color of the wood along the boardwalk. Darken the shirt and hair on the main figure with Ultramarine Light.

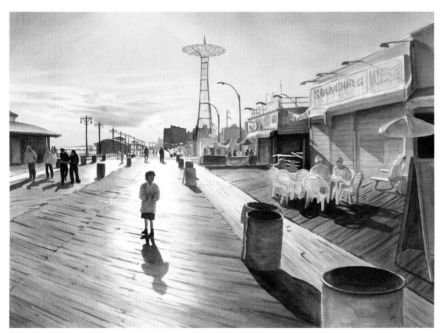

9

Begin the Darkening Phase

Darken the figures and their shadows on the left side of the piece with Ultramarine Light and Indigo. Use Indigo to further darken the building behind them, and the distant cans. With Ultramarine Light, darken the shadowed sides of the buildings on the right. Deepen the shadows cast by the table and chairs, the foreground cans, and the main figure using Indigo and Ultramarine Light. With the same colors, add some darks to help further refine the umbrella area. Darken the shorts and shoes on the main figure. Bring washes of Ultramarine Light into the wood of the boardwalk, darkening the sides, especially on the right side of the painting. Indicate spaces between the boards randomly with Burnt Umber.

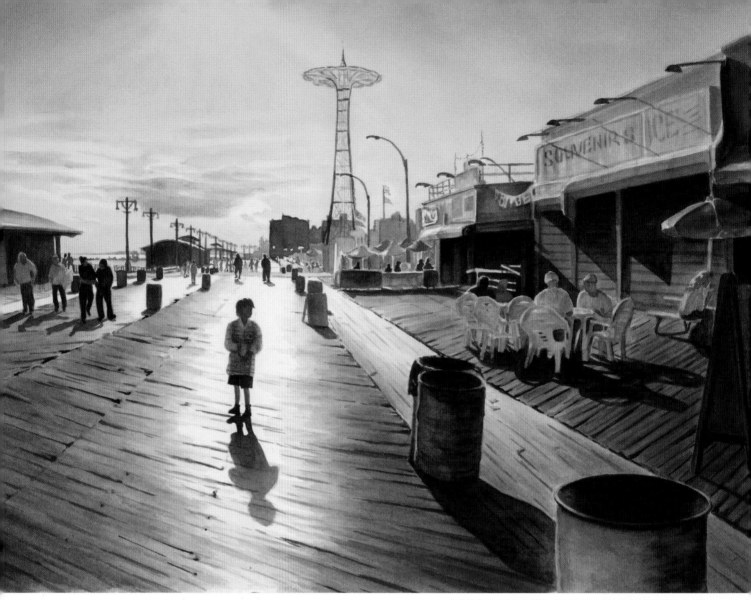

10

Draw Attention to the Main Figure

When painting a figure in silhouette, a lot of detail is not necessary; however, it is more interest-ing to have a hint of color rather than just a black shape. To finish this piece, do everything you can to emphasize the main figure. Add just a few more darks to his clothing. Darken the board-walk, especially in the foreground, with layers of Ultramarine Light and Burnt Sienna, leaving the fading light to shine over the main figure. Darken the suggestions of spaces between boards with Burnt Umber and Indigo.

All that remains now is to darken the right side of the piece to keep it from competing with the main figure for the viewer's attention. First, tone down any bright whites on that side with a wash of Lemon Yellow. Bravely deepen all the shadows with Indigo. Greatly darken the cans and the sign. Lay a unifying wash of Ultramarine Light right over everything in the foreground on the right side, including the table and chairs, the figures and the building.

before&after

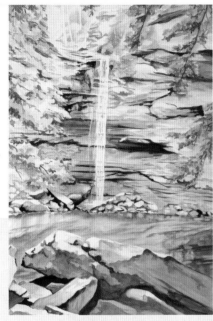

BEFORE

This painting looked finished when viewed close up, as watercolors tend to do, but paled when viewed from just a few feet away.

Boosting the value contrast will increase the illusion of depth.

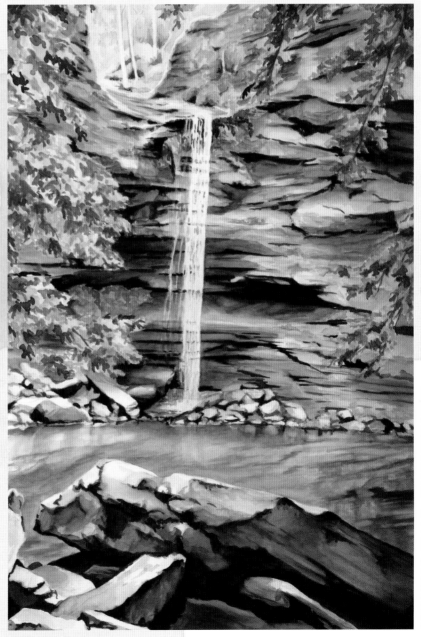

The areas around the top of the waterfall were darkened to help draw the eye to the region, creating a stronger focal point, which always enhances the sense of depth.

Deepening the colors and boldly adding rich darks brought the piece to life.

Notice the marked increase in the feel of three-dimensionality brought by the additional value contrast.

AFTER

ARKANSAS FALLS 22" X 15" (56CM X 38CM)

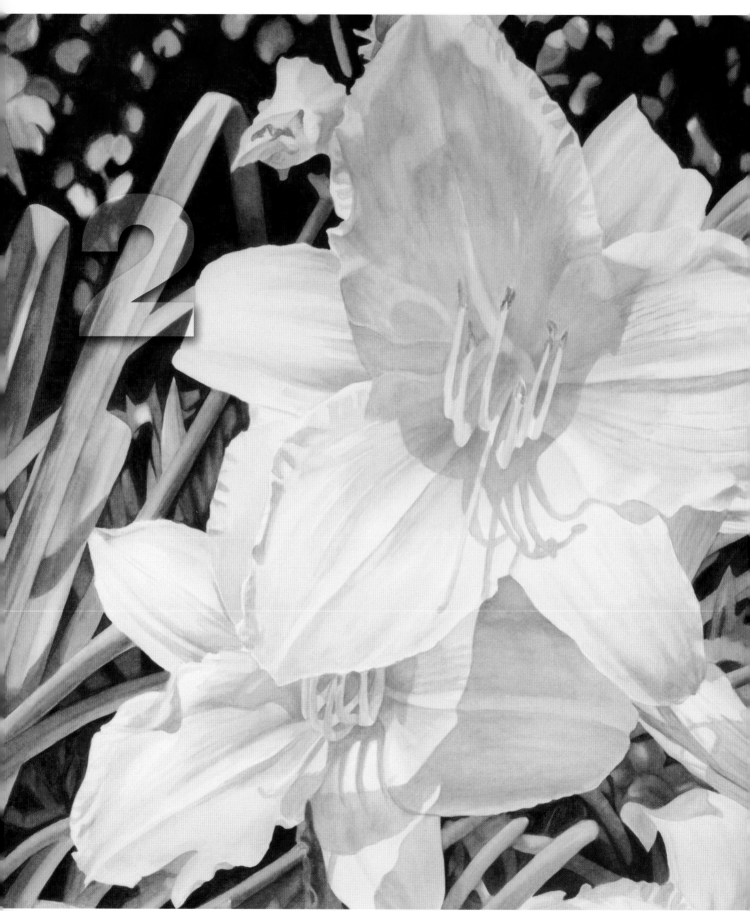

GOLD MEDAL FLOWER 22" X 30" (56CM X 76CM)

color saturation

Even an ordinary, mundane subject can be turned into an exciting painting with the addition of vibrant color. You can add color that isn't really visible, or just boost it in areas where you spot a hint of reflective color. This chapter focuses on using color to accentuate your focal area and increase depth. You can use *color saturation* in particular to increase the depth of a piece. This refers to using a high concentration of one color in your focal area. The eye will be drawn to an area of strong color. The addition of one strong color can be used to help create a focal point where one is lacking, or to make an existing focal point stronger. This does not mean, however, that you should use just one color in your focal point or that you shouldn't use that one color anywhere else in the piece.

COLLABORATIVE COLOR

A high concentration of yellow is used here in the flower's center. The yellow is repeated in the petals, shadows and leaves. The bright greens allow the pale pink tones to visually come forward in the picture plane. A very dark but bright shade of blue is used in the background, the leaves and the darker areas of the petals. A black or duller blue shade would have given the piece a dreary feel.

Carrying Color Throughout for Unity

For color saturation, you want to create an area of strong, vibrant color, but not an area of foreign color. The idea is to draw the eye into the piece with your focal point and then keep the viewer looking around the painting as long as possible. It is vital to the overall look of a piece that any new color introduced should be used in more than one area of the painting. A color brought into a piece in only one place will attract the eye, but not in a good way; it will appear out of place.

Avoid introducing a new color into the background of a piece unless you intend to also bring that same color into the foreground to integrate it. A foreign color in the background could draw the eye of the viewer away from your focal point. Detracting from your focal point will decrease the visual depth. If you are painting a figure and bring in blue for the sky behind it, look for other places that you can bring in that same blue—in shadows, hair or clothing. By using the new color in multiple places throughout the piece, you will create a sense of unity.

COLOR CONSISTENCY

A high concentration of yellow in the center of the wheel is repeated in the wood of the fence and wheelbarrow, in the grass and in the wheelbarrow's body, tire and handles.

REPEATING VARIATIONS OF THE STAR COLOR

The vibrant orange tones of this hibiscus are picked up in other areas of the painting: in the wood floor at the bottom left and top right, in touches on the leaves, and in the color on the railing. They are watered down a bit to be less vibrant but are still clearly visible.

How Creative Can Color Get?

You might need to add color where you don't see any for the sake of improving your painting. How do you know where to add imagined color so it makes sense? Begin by looking at the world around you differently. Look for nuances of color everywhere. Learning to really see what is before you, not taking for granted that green is just green, is key to creating any work of realism. Seeing color in life will help you decide where to add it to a painting in a way that will enhance reality.

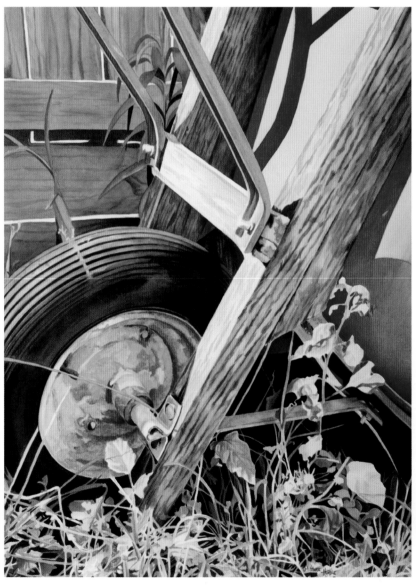

BOTTOM OF THE BARROW 30" X 22" (76CM X 56CM)

46

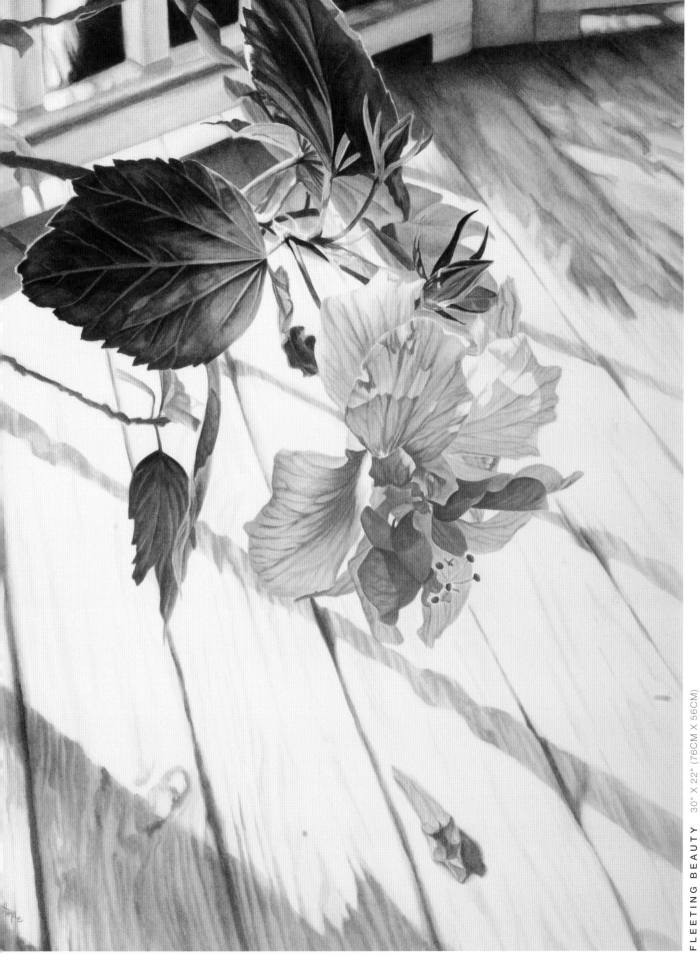

USING CONCENTRATED COLOR

We will use a high concentration of color in the focal area of this rocky Southwest landscape to help increase the visual depth of the piece. As in most paintings, several techniques will be used to draw the eye to the focal area; however, concentrate on the use of color as you work. The viewer's eye will be drawn to a vibrant patch of Burnt Sienna and Permanent Red, offset by the Gamboge behind it.

COLORS

gamboge
magenta
permanent red
burnt sienna
burnt umber
olive green
cyan
ultramarine light
indigo

1

Create a Simple Line Drawing

Draw faintly, just dark enough so that you can make out the lines. This will make any errant lines easier to erase later on. Draw the major elements in the composition and include shapes you want to keep as white paper.

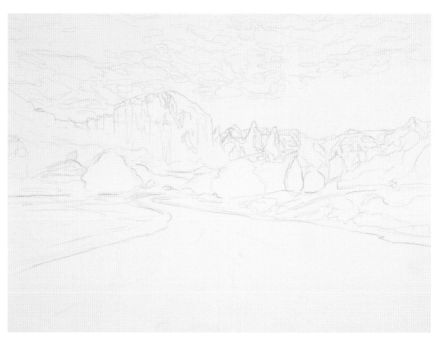

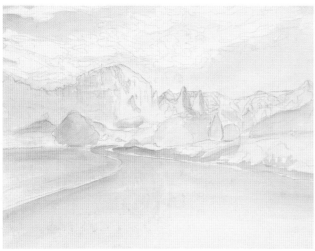

2

Start With Pale Layers

Begin with a pale layer of Cyan in the sky, carefully painting around cloud formations. Quickly soften edges around the clouds as you go. Leave a few harder edges around the tops of the clouds for definition, but don't make them too uniform in size and shape. Next, block in the major areas using just enough paint to see your color choices. Use Indigo for the roadway, putting color only along the edges and the far section of the road. Remember to paint around and save the important whites. Use Gamboge for the distant mountain's shadow areas and the highlights on the largest rock. Paint layers of Burnt Sienna in the foreground and the shadowed areas of the larger, nearer rock formations. Add a few touches of Olive Green to the foliage areas.

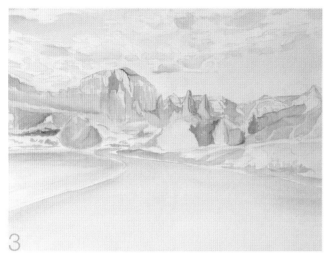

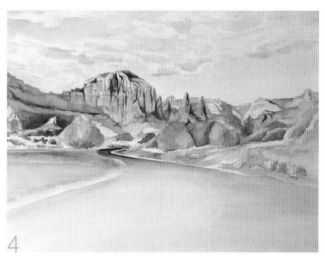

3

Layer Color to Develop Depth

Ultimately, the sky should look as though it has a great depth of its own, so you'll want it to fade into the distance. To begin to create that effect, add layers of Cyan to the top left of the piece. Paint soft shapes using Ultramarine Light to indicate the bottoms of the clouds, keeping all the edges soft and fuzzy. Start to give the rocks a craggy feel by painting the lightest shadow areas, always painting around whites and lights. Use Burnt Sienna in the focal area: the larger rocks at the end of the road. Use Burnt Umber to lay in a few deeper shadows (still keeping the piece quite pale overall) on the lighter, more distant rocks and on the deeper shadows of the larger rock as well. Add another Olive Green layer to the foliage that you want to appear farther away. Bring a touch of Gamboge into the foliage and the foreground to help tie the piece together. Darken the back edge of the ground in the foreground using some Burnt Sienna. This will help to anchor the land and make it "lie down." It should appear to recede into the picture plane, rather than looking as if it is lying vertically on the paper's surface.

4

Build Shapes, Shadows and Texture

Continue to slowly build up the look of texture on the rock surfaces by adding additional layers of shapes and shadows. Deepen the shadow on the distant formation using Ultramarine Light. Bring violet (Ultramarine Light plus a touch of Magenta) into the shadows of the rock surface. The violet can also be brought into the underside of the clouds for additional depth. Use Burnt Umber to accentuate some of the deeper crevices. Mix some Ultramarine Light into Olive Green to create deeper tones for the foliage that is farther away. Usually, foliage should get lighter and fade into the distance to create atmospheric perspective (see page 64). In this case, however, it is the rock formations and the sky that should fade. The visible foliage stops at the base of the rocks, so it appears darker than in the foreground. Use Indigo to further darken the far section of road.

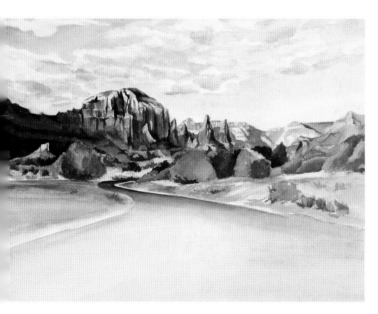

5

Continue Darkening and Add Detail

Add Permanent Red to Burnt Sienna for a brighter color, and paint it into the rocks in the focal area. Mix greens using combinations of Olive Green, Ultramarine Light, Burnt Sienna and Burnt Umber. Use these greens to give some form to the foliage, with your darkest greens reserved for the most distant foliage. Remember to think in terms of "layers of depth" as you paint. Use Burnt Umber and Indigo for the really dark ridge of rock on the left, and add touches of that color to the deepest crevices. Add a bit more definition to the clouds, still keeping them soft. Using Burnt Sienna, Gamboge and a hint of Burnt Umber, add some definition to the foreground, darkening the ground as it recedes. Notice how much brighter your white and lighter areas appear as you darken the areas around them. Dampen the road and drop in a touch of Gamboge and Burnt Sienna to tone down the bright white.

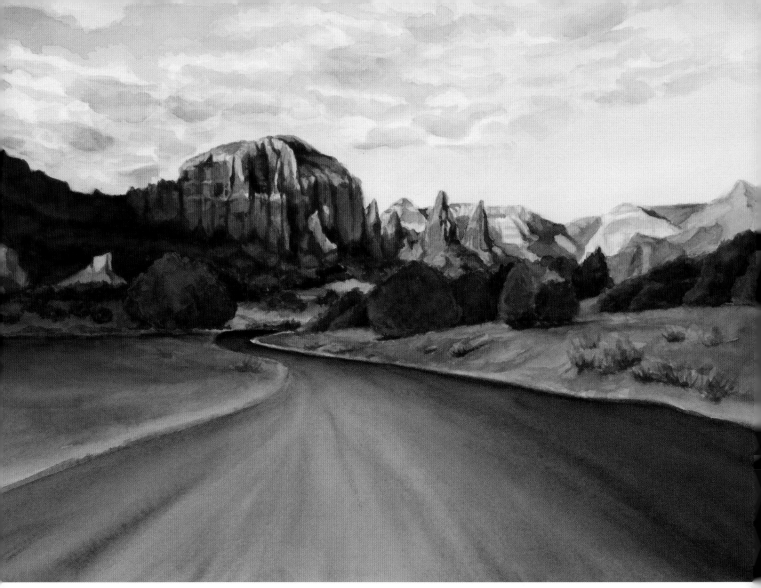

6

Finishing Touches

A final wash of Burnt Umber and Indigo is needed on the dark ridge
to make the piece more dramatic. Darken the trees and foliage. Add
another layer of Cyan to the sky above the dark ridge, leaving the rest
of the sky lighter to help draw the eye. Moisten the roadway and paint
with a mixture of Indigo and a touch of Magenta. Paint a few shadows
under the trees using one of your darker green shades. The road
should be darker on the edges and very dark in the distance. Lastly,
darken the foreground on both sides of the road. This area is of lesser
importance, and you want to lead the viewer back into the piece. Paint
over the entire area, using a watered-down wash of the road color.

Staying Focused: The Limited Palette

To paint with a limited palette means that you limit the number of colors you use for a painting. You may want to use only three basic paint colors, but it doesn't have to be that limited. I generally use a fairly limited palette for each piece, usually in the neighborhood of eight colors. This is not always intentional; often it is just all that the painting needs.

With transparent watercolors, you have the unique opportunity of being able to create the effect of many paint colors even when working with a very limited palette, through the use of layering. Multiple layers of color can simulate a variety of hues, as shown in the star exercise on page 20. This being the case, you should be leery of using too many different paint colors. Too many colors can make a painting appear busy and confuse the eye of the viewer. This will only detract from your focal point.

Color can be used to set a tone or overall mood of a piece. This is yet another reason for using a limited palette. For example, you may need cool colors to suggest a rainy day, or to create a somber mood. You might want to use only warmer colors for a bright outdoor scene, or to convey a feeling of excitement. I may plan a palette of colors to use if I want to capture a specific mood. Most often, however, my color choices are more intuitive, evolving and changing as the painting progresses.

Train Yourself to Look for Color

Many people experience difficulty seeing color. If an object is basically green, they see only green. In fact, however, light bounces from object to object, so colors from one object are reflected onto the next. These reflections are often very subtle and you have to look closely to see them. Try setting up two separate still lifes: one comprising only white objects, the other only black. In order to paint these still lifes, you will be forced to look for color to add interest and to differentiate one object from the next. Colors from other things in the room will cast faint shadows for you to find.

FACE VALUE 22" X 30" (56CM X 76CM)

LAYERING EXPANDS A LIMITED PALETTE

This piece required a lot of layering. Only seven different tube colors were used. Due to the many color combinations possible through layering, the piece appears quite colorful upon close inspection. When you think of money, you think green; but notice the many colors that are really painted here.

Bright vs. Dull

How do you achieve color saturation in your focal point and also maintain a sense of color unity without losing depth? This is where *intensity*, or brightness vs. dullness, comes into play. You will want to use duller tones in your background areas, reserving your more vibrant colors for your foreground and focal point. Colors are at their most intense right out of the tube, mixed only with water. This is what I mean when I refer to *pure color*.

To dull a color, add a bit of its complement (its opposite on the color wheel). You will need only a small amount; you don't want to completely change the color, only dull it a bit. Adding too much of a color's complement will give you a brown or black.

Many colors can be brightened up a bit by laying a pale wash of Lemon Yellow over a dry, already-painted color that appears too dull. Sometimes this changes the hue a little, but it is often preferable to the dullness. It is most effective with reds and other warm colors. And although yellow gives blues a greenish cast, it can turn a dull blue into a vibrant blue-green. A warning, though: do not attempt to brighten a purple with a yellow wash, as you will end up with an even more dull brown or gray.

POSITIONING DULLER COLOR TO SUPPORT THE SUBJECT

The use of duller colors in the background—on the distant bike, the shadow cast by the bike, and the grass and sidewalk—both gives the air of a bright sunny day, and brings the focus back to the bike in the foreground.

pure color

pure color

mixed purple

PERMANENT RED | ALIZARIN CRIMSON

The reds are more orange in tone, but slightly brighter, when a wash of Lemon Yellow is added over them.

CYAN | SAP GREEN

With the addition of yellow, the Sap Green is considerably brighter; the Cyan, however, just turns blue-green. While it's a brighter green than the Sap, it is slightly duller than the Cyan, as more light is blocked from the paper. The Cyan/Lemon Yellow combination can add vibrancy to foliage, however.

ULTRAMARINE LIGHT + MAGENTA

Purple and yellow are complementary colors and therefore make a brownish gray when layered.

+ layer of Lemon Yellow

+ layer of Lemon Yellow

+ layer of Lemon Yellow

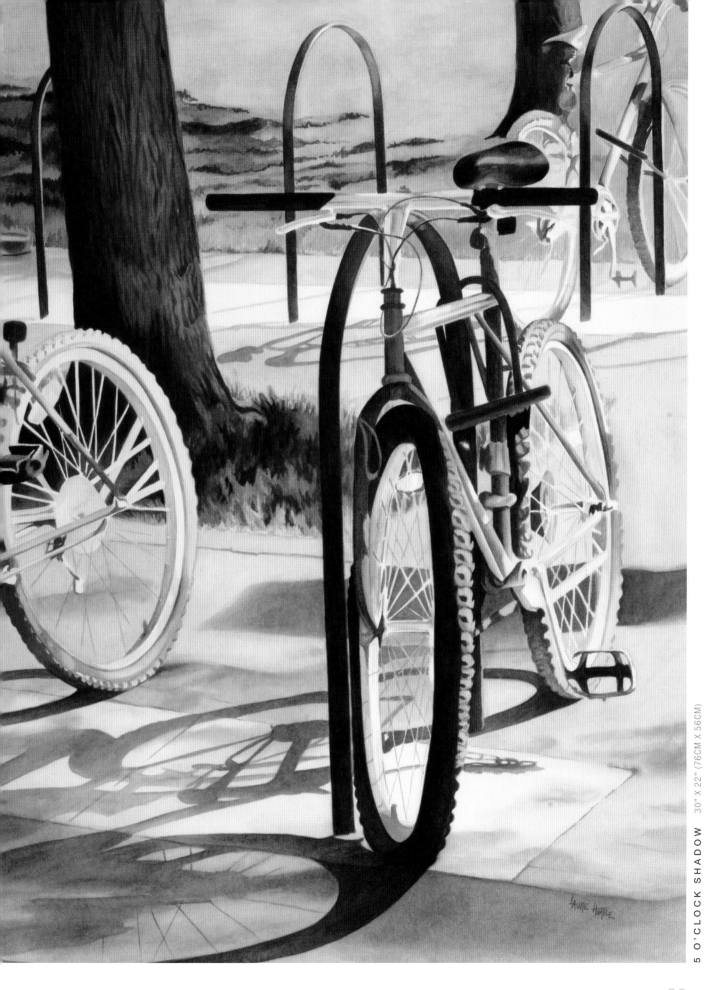

5 O'CLOCK SHADOW 30" X 22" (76CM X 56CM)

Color in Light and Shadows

Flooding your shadow areas with color can add unexpected beauty to a subject. If there are shadows in your focal area, you can paint them using the same vibrant colors as the objects that cast them. You can reserve duller colors for shadows in the less important background areas.

It is always a good idea to give as much attention to painting shadows as you do to painting the main subject matter. Although they will vary in contrast and vibrancy, you'll always want to incorporate colors into your shadows, for depth and interest.

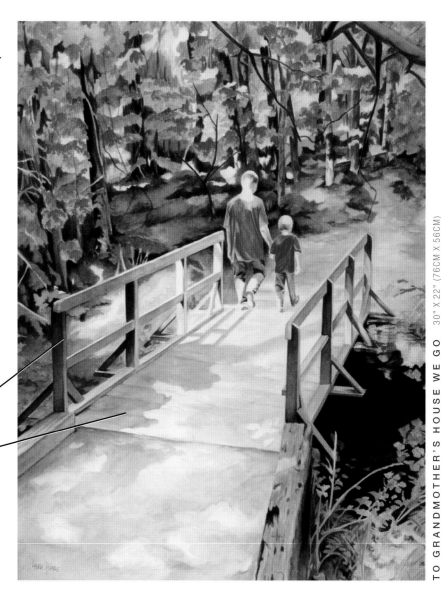

Notice the color in the shadows on the wood of the bridge.

A wide array of colors and values are in the shadows on the ground.

TO GRANDMOTHER'S HOUSE WE GO 30" X 22" (76CM X 56CM)

Revisit the Star Exercise

Use color saturation to make one star stand out. Here, one star is painted a darker red than any of the others.

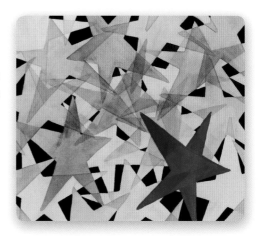

COLOR SATURATION: FLORAL

In this demo you will use a high concentration of one color in the center of the main daffodil to draw the viewer's eye. Using the same color in other areas throughout the piece will give the composition unity. As you practice layering with pure color and painting around your whites, you will build on what you have learned so far. This piece will have both value contrast and rich color.

COLORS

lemon yellow
gamboge
magenta
alizarin crimson
olive green
cinnabar green light
cyan
indigo

1

Create a Pencil Drawing

Carefully, but lightly, draw your plan. These daffodils are predominantly white, so subtle shadows will make all the difference. Therefore, you will want your drawing to be quite detailed so that you can more easily save your whites.

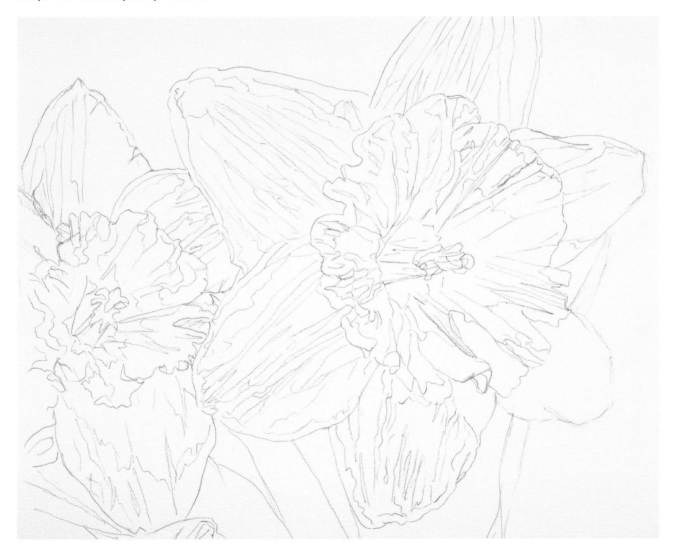

Start With Very Thin Layers

Begin applying very thin layers, painting carefully around your whites. Using Cyan, paint shadow areas on the outer petals. Paint shadows on the inner petals using Lemon Yellow. Put a light wash of Olive Green on the leaves and just a touch in the center of the flowers. Mix Olive Green with a little Indigo and use this combination in the background to define the petal edges.

3

Define the Flower Shapes

Bring some Gamboge into the inner petals. Also work it into the outer petals, washing over the Cyan in places to create an additional color. In the flower centers, use Lemon Yellow for the lighter areas and another layer of Olive Green for the darks. Paint another layer of Olive Green on the darker areas of the leaves. Bring the Olive Green into the background at the top of the painting; this will help to balance the leaves. Using the Indigo/Olive Green mixture, suggest some background under the flowers, again using this background color to define the edges of the flower petals.

4

Introduce Bolder Color

You can be a little bolder with color at this point, as the painting is now blocked in and you are ready to begin to darken and beef up the color. Using Gamboge, bring more shapes into the outer petals. Paint light layers of Magenta on the shadow areas of the petals that are the farthest back. Pay careful attention to the edges of the petals. Add a few subtle layers of Magenta on the inner petals. Paint a bold layer of Gamboge on the darker parts of the inner petals. Paint the darker leaves with Olive Green darkened with some Indigo.

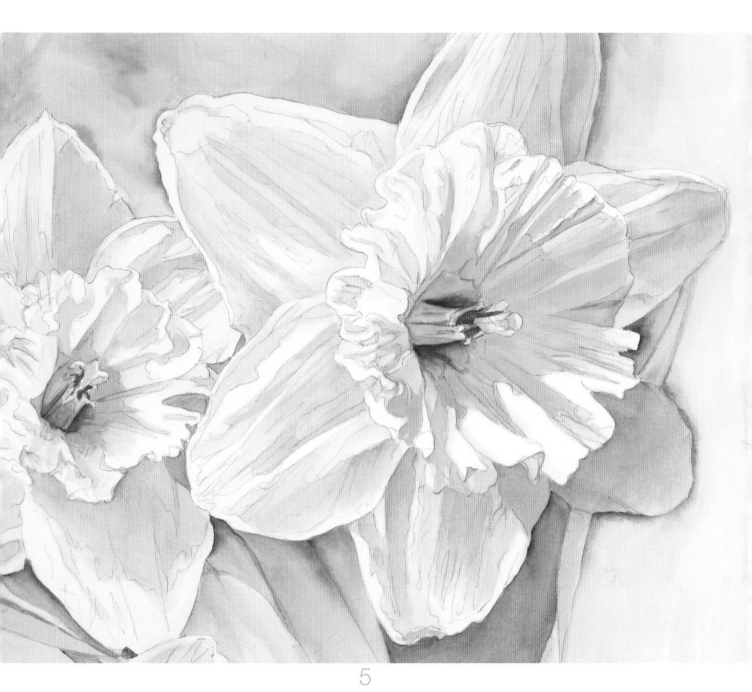

5

Separate the Petals

Add another layer of Gamboge to the leaves and the outer petals. Use Alizarin Crimson in the flower centers and subtly on the inner petals. Paint a heavier layer of Gamboge on the shadowed areas of the inner petals. The outer petals should be getting gradually darker, making the white areas of the inner petals seem more prominent. Separate the petals using pale washes of Cyan along the edges of the lowest petals.

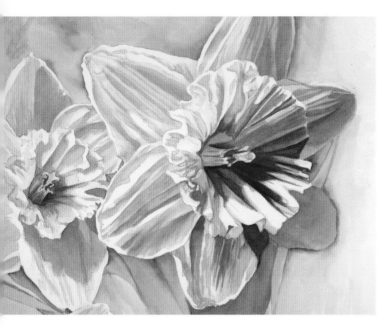

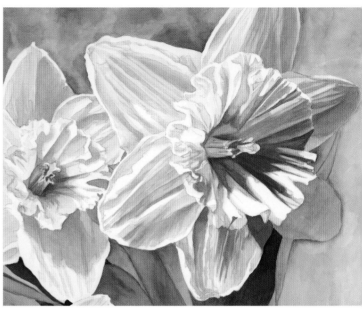

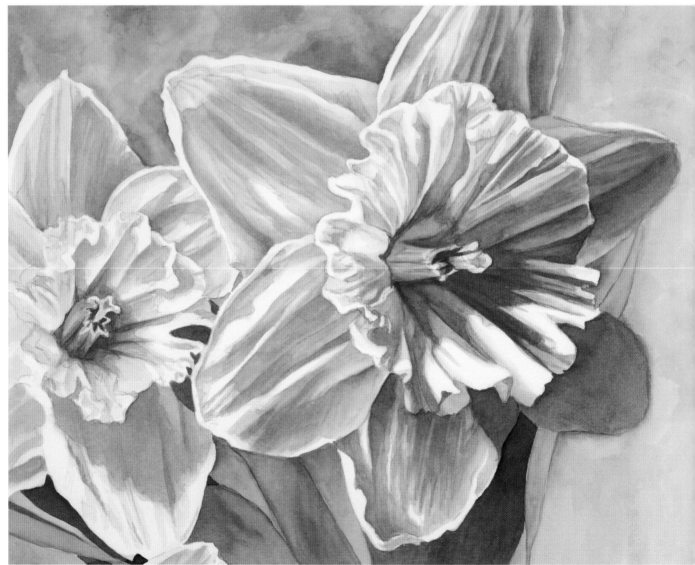

6

Bring On the Color

Working with Alizarin Crimson, add light layers on the outer petals. Darken the petals that are farthest back, allowing those in front to stay lighter and visually come forward. Bring in bold amounts of Alizarin Crimson in the flower centers, as this will become the splash of color in the focal point.

7

Brighten the Flowers and Add Color to the Background

Paint a layer of Lemon Yellow in the background and on the leaves. Bring a few touches of Lemon Yellow into the flower centers to brighten them. For even more color, add Cinnabar Green Light (or your brightest green) to the flower centers. Use this same green in the background. The more color you flood into the background, the more your flowers will stand out and the more depth you will create. When the background is dry, bring some Cyan into it as well. Mix a deep green with a combination of Cinnabar Green Light, Olive Green and Indigo and use it for the darks in the leaves.

8

Deepen the Shadows

Darken the shadows on both the inner and outer petals using washes of Cyan, Magenta and combinations of the two. Since the main flower is on an angle, darkening the petals that are farthest back will add to the illusion of depth.

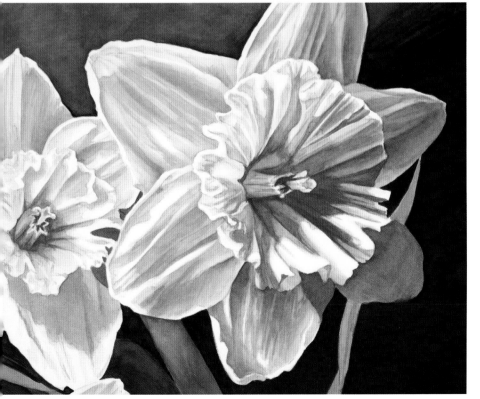

9

Develop the Background

Darken the leaves using layers of your greens and some Indigo. Use Cinnabar Green Light toned down slightly with Olive Green to darken the background on the top left. For the rest of the background, use a deep violet (Indigo with a little Magenta mixed in). Lift out a few sun rays where the green and violet meet; this makes a nice transition between the two colors and adds a design element to the composition. Notice how much lighter in tone the flowers appear after you darken the background. This helps to pop the flowers out into the foreground.

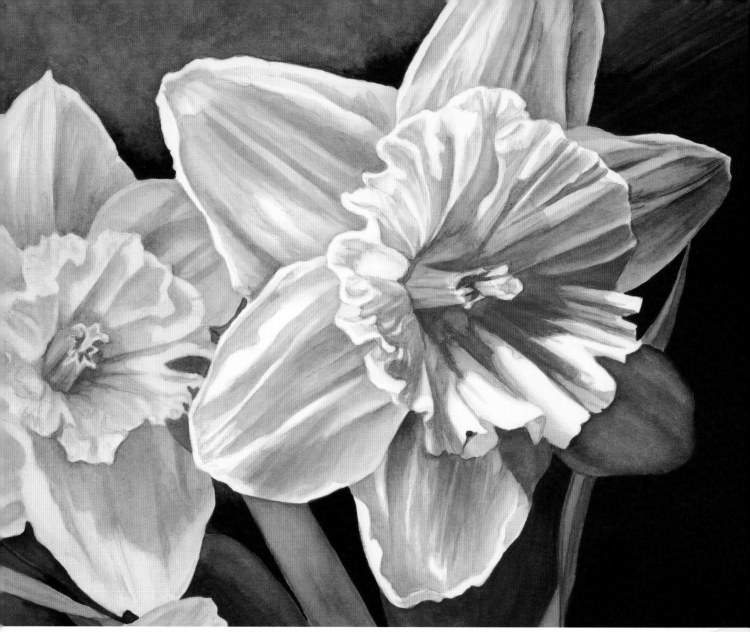

10

Finishing Touches

Blend some of the violet mixture into the green background at the edges of the petals at the top of the piece, so the flowers will really stand out from the background. Add another layer of darkness to the outer petals, paying careful attention to the edges that separate the individual petals and the edges of the inner petals. A pale wash of Cyan along the outer edge of the innermost petals will bring the flower center forward.

Add some final detail to the leaves. Add a final wash of your mixed deep violet over the previous deep-violet layers to really darken and even out the background wash on the right. Lift a little color off the darkest petals in this area, just enough so they stand out a little. By darkening and then lifting, you will create a desirable softer edge on these background petals. The focal point should be the center of the large flower. The smaller flower has highlights and competes a bit for the attention of the viewer, so to push the smaller flower back and reduce its prominence, paint a pale wash of Cyan mixed with a touch of Magenta over the entire small flower. This will tone down the white and light tones and soften the edges a bit, allowing the focus to be right where you want it: the center of the larger flower.

before&after

Use color saturation to strengthen your focal point.

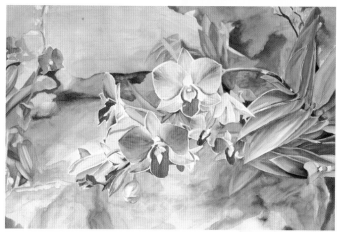

This painting had a predominance of one color in the focal area, and it had depth, but could it have more of both?

The background wasn't really doing anything to add a sense of three-dimensionality or accentuate the flowers.

BEFORE

Adding deeper color to the flowers in the focal area helped to draw the viewer in and made the whites appear brighter.

Adding darker, richer colors with softer edges made a big difference.

The predominant color of the flowers was layered into the background along with the darker colors to help keep the viewer's eye moving throughout the piece.

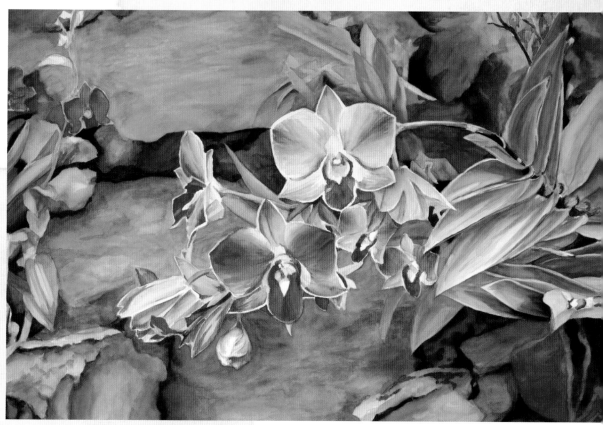

AFTER

HAWAIIAN FLOWERS 15" X 22" (38CM X 56CM)

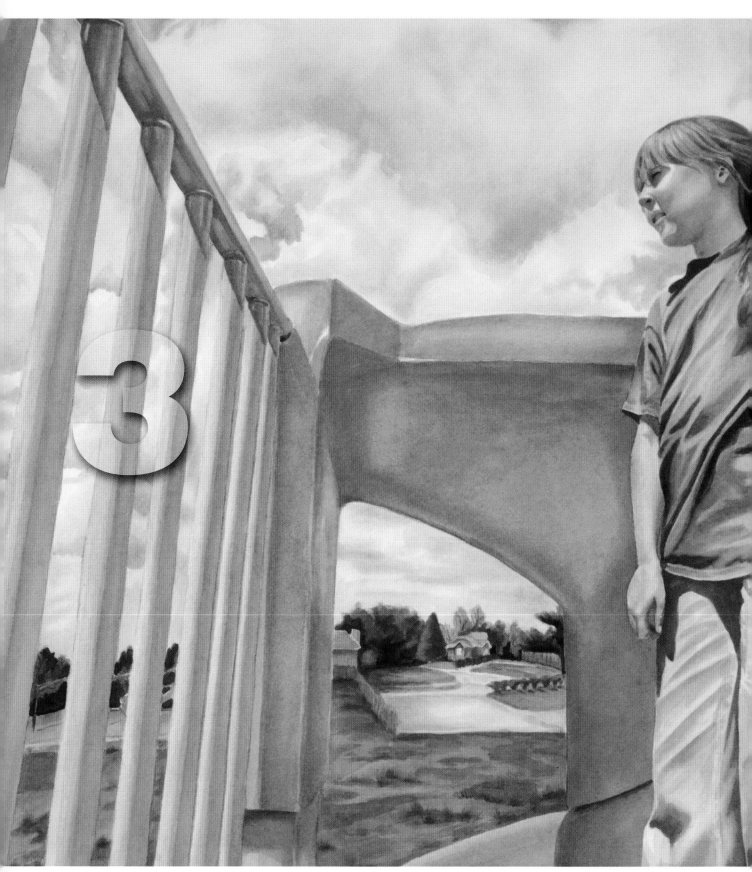

GAINING SOME PERSPECTIVE 22" X 30" (56CM X 76CM)

perspective

Some artists love the act of drawing, while others find it to be a laborious task. Oil painters can just paint their way to realism, but to paint realistically in watercolor usually requires a drawing. This is the time, before you ever put paint to paper, to consider perspective. This chapter focuses on some easy ways to use very basic principles of perspective to add depth to your work. Getting lost in a complicated perspective issue can be frustrating, and unless you have a real love of drawing, this is an area where you might want to consider simplifying. You should enjoy the entire process of creating an artwork, or there really isn't much point in doing it.

A GRAND VIEW

This piece has an unusual vantage point: the viewer is looking up and out. You can almost feel the dizzying effect of the sky whirling around you. The angles of the railings draw the viewer in and lead directly to the figure. This figure is foreshortened: part of the figure (the girl's left hand) is extended out toward the viewer. The perspective is so extreme that the hand had to be drawn larger than the head for it to appear correct.

Perspective Drawing

In painting, your drawing doesn't have to be mathematically perfect; it just needs to appear correct. Incorrect perspective will inevitably flatten a piece and kill any sense of realism and dimension. If the wall of a building is drawn at an impossible angle compared to the rest of the piece, there is little hope of creating the illusion of depth. Understanding some perspective basics will help you create an underlying drawing that looks proportionate and realistic.

Perspective is often split into two categories: *atmospheric* and *linear*. *Atmospheric perspective* refers to the way our atmosphere causes things at a distance to appear with less clarity, more muted in color, and with less contrast in value. That means that anything you can do to soften edges, cut contrast and mute colors in areas you want to appear farther away will increase the illusion of depth in your painting. In watercolor, this can often be accomplished with a unifying wash, which we will discuss further in chapter 5.

Linear perspective involves methods that make individual elements in a painting appear three-dimensional and in proper proportion with one another. The most commonly used types are one-, two- and three-point perspective. The "point" refers to *vanishing points*, usually on the horizon line, at which parallel lines in the composition seem to converge.

One-Point Perspective

In one-point perspective, there is a single vanishing point on the horizon line at which parallel lines that represent the receding sides of objects seem to converge. Vertical lines stay vertical, and horizontal lines that represent the front-facing planes of objects stay horizontal. This type of perspective pulls the viewer's eye deep into the scene from the very first glance.

Two-Point Perspective

In two-point perspective, there are two separate vanishing points on the horizon line. Most objects are situated so that more than one of their planes is visible. Each set of parallel lines recedes to a common point. Vertical lines stay vertical here as well. It is not unusual for a drawing to have many vanishing points along the horizon line, but individual objects within the drawing are done in the same perspective. The lines for each object recede toward that object's own two points on the horizon. Many works of art are done with some form of two-point perspective.

Three-Point Perspective

Three-point perspective involves a third point that is not on the horizon line but falls somewhere above or below it, often off the paper. This third point is where the vertical lines, which in other types of perspective remain vertical, now converge. This type of perspective is used to exaggerate forms, and is most often used when depicting views from extreme vantage points.

Representations with unusual vantage points, size and scale also employ principles of linear perspective.

ONE-POINT

Notice that all the lines and elements seem to radiate out from a single point off in the distance.

BEHIND MGM 27" X 21" (69CM X 53CM)

OFFICER'S RETREAT 30" X 22" (76CM X 56CM)

TWO-POINT

There are two main vanishing points at work here, both well off the paper. The horizon line would be near where the porch floor meets the wall, and both points would fall along that line: one to the far left, the other to the far right. Notice that two sides of the porch posts are visible.

THREE-POINT

Any time you are looking way up at something or way down upon it, you will need to use three-point perspective. In this case, the third point lies far beyond the top of the paper. Notice that the lines of both the building and the sign all seem to converge toward the top of the painting.

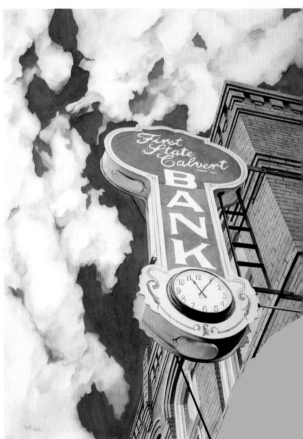

TIME AND MONEY 30" X 22" (76CM X 56CM)

Consistency Tops Complexity

A painting does not have to be intricate to be good. When it comes to perspective and realism, the most important thing is to place all of the elements in the painting as they would appear when viewed from the same vantage point. For instance, if you are painting two objects on a table, you wouldn't want to be looking up at one and down on the other. Use perspective to your advantage, placing items in a painting in a way that will increase depth and draw attention to your focal point.

Vantage Points

One thing that is sure to make a piece stand out is an unusual vantage point. When deciding what to paint, keep in mind that almost any subject you can conceive has probably been painted before. It is up to you to find a way to make your work unique and fresh. Viewing your subject from an extreme perspective can make that difference. Perhaps you can look at your subject from above or below or from some unique angle. For example, a subject that is usually presented from a distance and in its entirety can be depicted close-up and cropped. Use your imagination and devise a way to present your chosen subject in a new fashion.

Make sure that whatever vantage point you choose to work from, you use it consistently throughout the piece. More than one viewpoint in a piece will confuse the viewer and visually flatten out the work.

THE VIEW FROM BELOW

This is one of my "realistic-abstract" pieces. It is a painting of something real, but the vantage point, cropping and color use give it a more abstract feel. The viewer is looking up at an extreme angle, seeing ground, a marker, a garden hose, grass and roots, with some sky in the distance.

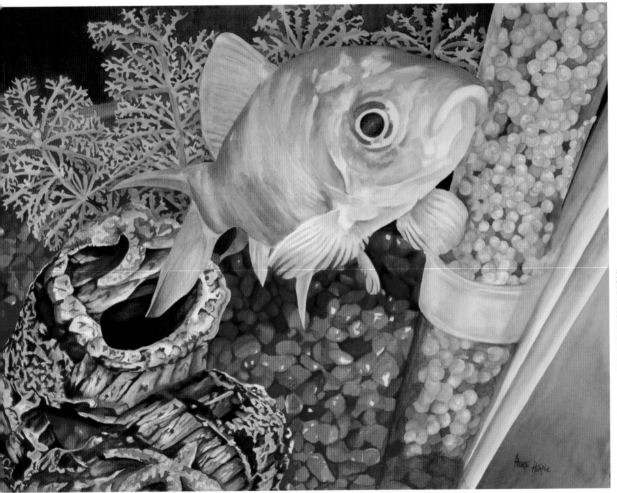

MICRO-MANAGEMENT 30" X 22" (76CM X 56CM)

TWO GALLONS 22" X 30" (56CM X 76CM)

THE VIEW FROM ABOVE

Here you are looking down on the subject at an extreme angle. Notice how everything gets smaller as it recedes into the picture plane. The fish appears to be swimming up and out at you.

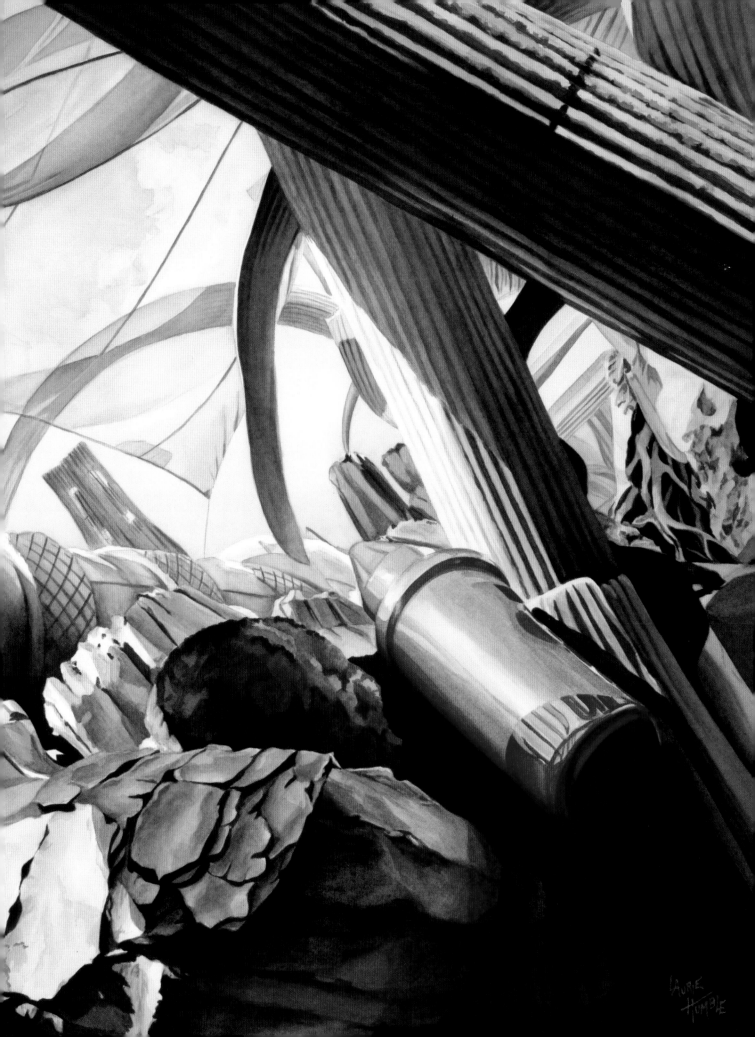

Scale and Size

Remember that objects that are closer to you generally appear larger than objects in the distance. Things diminish in size as they recede into the picture plane. Always be mindful of the scale of the individual elements in your composition. The scale should make sense if you wish to show depth. For example, you would not want to have chairs that look larger than the figures, or a piece of fruit that seems larger than a bottle of wine. A mistake of this kind will decrease visual depth because the picture will look less plausible.

Due to the demands of perspective, you may, however, have a chair that actually is drawn larger than the figure if that chair is in the foreground and the figure is farther in the background. The key is to use perspective to make different-size elements appear to make sense within the picture plane.

Examine your initial drawing with an open mind and a critical eye. Look for anything that visually doesn't make sense. For example, if you have drawn one arm of a figure longer or bigger than the other, does it appear correct because of the perspective in which it is drawn, or does it appear to be an error? The drawing stage is the time to correct these types of problems, so it's imperative to really take the time to check for inconsistencies before you begin to paint.

I learned this lesson when working on *Son & Shadow* (see page 13). I spent a great deal of time on my initial drawing, working carefully from my reference photo. (Notice how large the legs and feet of the central figure appear in comparison to the upper body and head in the reference photo.) Certain I finally had my proportions correct, I stood back to admire my efforts. But, alas, the main figure appeared to be a pinhead! I was forced to erase the entire torso, arms and head and redraw them much larger to match the legs. Luckily, I caught the error before I began painting.

Size Always Matters

If you are working on a more abstract or nonobjective piece, where point perspective and scale are irrelevant, the size of the shape that you use in your composition can aid in establishing a sense of visual depth. A shape that is different in size from all other shapes can become a focal point.

CONVEYING DEPTH THROUGH DIFFERENCE OF SCALE

In reality, these two rock formations are similar in size, but one is farther away. Notice the difference in scale necessary to make one appear to be off in the distance.

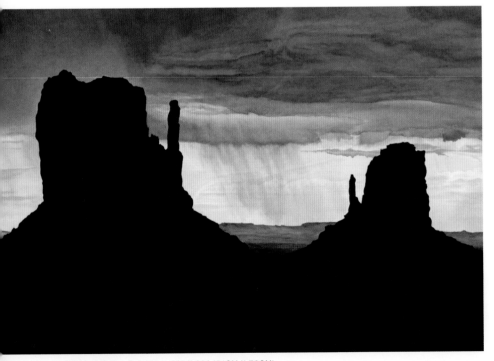

AT LAST, RAIN 20" X 30" (51CM X 76CM)

Revisit the Star Exercise

Add one star that is smaller than all the others. Notice that no matter what color you choose to paint it, it will still stand out because it is different. You may want to lighten the darkest star you painted in the previous chapter if it is competing with the small star for attention. I created a completely different star painting for this chapter. You may want to do more than one of these exercises as well if you want to save one for a color reference.

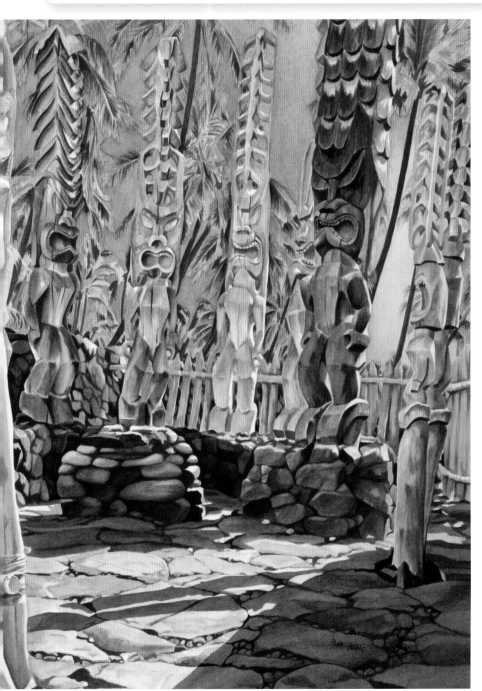

SIZING UP YOUR SUBJECT

Here, the focal figure is not only shadowed and darker but also slightly larger in size than the others. While it is closer to you, its size is exaggerated a bit to give an air of importance. Try not to get carried away when overstating size, though; taking it too far will make the scene appear implausible.

ANGER MANAGEMENT CLASS 30" X 22" (76CM X 56CM)

Overlapping and Underlapping

No matter what type of art you are creating, from nonobjective to photorealistic, the overlapping of shapes will add depth. Any time you place one thing in front of another, you are producing the illusion of space. A painting just cannot appear completely flat if any element has something behind it. The more shapes that overlap, the greater the illusion of depth you will generate.

When you prepare a drawing for a painting, try pencilling in just the foreground at first. Next, begin to draw elements behind the foreground, then add more shapes behind the first, allowing them to disappear behind your previously drawn foreground. This is a sort of backward way to overlap that I call *underlapping*. Generally, when you think about overlapping something, you think about it in terms of laying something down, then putting another layer on top. With drawing, however, it works better if you establish the uppermost layer first, followed by drawing what can be seen of the layers beneath. Approaching your initial drawing in this way, you'll create shapes that will lead the eye into the background which, in turn, increases the illusion of depth.

Your goal is to lead the viewer's eye throughout the piece, but then bring it back to the focal point. Find convenient ways to lead the eye to the focal area using elements within the composition. Use lines and shapes to your advantage by setting them up so that they guide the viewer directly to the main point of interest.

Angles can add a dynamic quality to a composition. Lines or shapes that cut across the picture on a diagonal generate added interest and depth. In a sea of paintings that are set up in a horizontal/vertical fashion, a piece with diagonals—especially if those diagonals lead to the focal point—will captivate the viewer.

OVERLAPPING ELEMENTS THAT LEAD THE EYE

This painting has many overlapping elements that help guide the eye through the work. The coffee cup draws the eye first, and then the other elements take the viewer through the piece. The overlapping newspapers add depth from the top down, and the other elements add depth from the front to the back. Repeated circular shapes help pull the eye back and into the piece.

LINES THAT LEAD THE WAY

Here, dynamic angles are used to break up the painting, but all lines and elements point back to the focal point: the gold-toned socket.

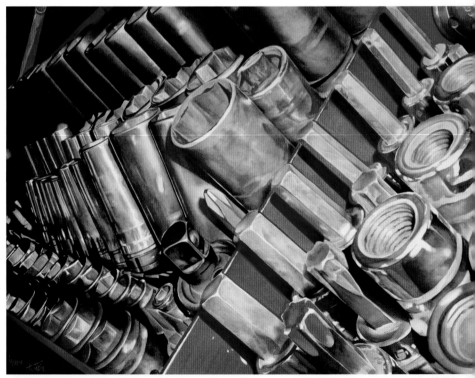

TOOLS OF HIS TRADE 22" X 30" (56CM X 76CM)

PERSPECTIVE: INTERIOR CORRIDOR

With this demo you will work with both linear and atmospheric perspective to create greater depth. Contrast and color, as discussed in previous chapters, are also important here. You will use gradated washes on the wall and floor. To avoid frustration, you may want to practice making a smooth transition from one color to another before you begin. You will get even more practice painting around your white and light areas. While this seems time-consuming and frustrating at first, with practice it becomes second nature. When it does, you will be amazed at the amount of depth you can achieve, and how easily.

COLORS

gamboge
magenta
alizarin crimson
burnt sienna
burnt umber
olive green
ultramarine light
indigo

1

Create a One-Point Drawing

Using one-point perspective, create a light pencil drawing. Your vanishing point should be off the paper to the center right. Remember that all of your horizontal lines should lead back to your vanishing point. If you were creating this piece with draftsmanlike accuracy, there should be a secondary vanishing point for the floor tiles. We won't concern ourselves with that for this piece, however, since we are actually painting only a few of the tiles and merely suggesting the rest.

2

Carefully Preserve Whites

The white and light spaces on the floor and the sides of the windows are all-important to this painting, so begin preserving them now. Paint the window awnings, being careful to save whites along the window edges with Gamboge. Also with Gamboge, paint around whites in the light fixtures. This will help them appear to glow later on. Add some Gamboge to the ceiling and the floor as well. Paint the interior wall with a very pale layer of Alizarin Crimson. Using Burnt Sienna, paint some medium tones in the floor tiles, leaving some whites between and on the surface of tiles that receive light from the windows. Mix a blue-violet using Ultramarine Light and Alizarin Crimson and suggest shadows on the ground outside the windows. This will help you see the window edges and make painting around whites easier.

3

Paint the Panes and Light Fixture Details

Mix Burnt Umber and Burnt Sienna and paint the trim between the window panes. Use the tip of your brush, with a light touch, to keep your lines as straight and steady as possible. Some variation is inevitable, so don't worry if it doesn't look perfect; you have many layers yet to paint. Using the same color, add some shadow to the ceiling and detail to the light fixtures. Don't get carried away, though; don't try to outline the fixtures. Paint some reflections of the window trim onto the floor tiles with a darker tone of Burnt Sienna. Mix a touch of Magenta with Indigo and paint the railings outside the windows. They are visible through only the first few windows due to the extreme perspective.

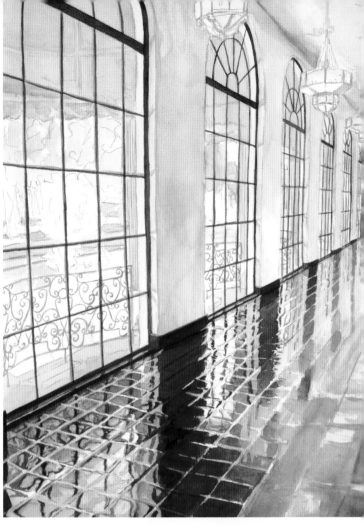

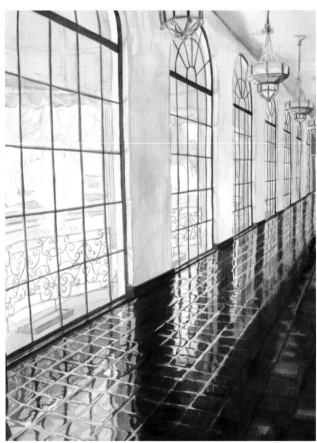

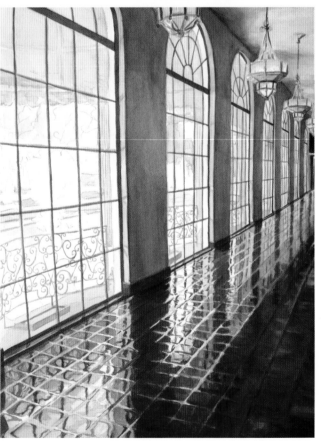

4

Add Shadows and Reflections and Suggest the Scenery Outside

Bring a little Ultramarine Light into the ceiling and the top of the interior wall to create a shadowed effect. Blend Gamboge into the wall where light is streaming in. Use Burnt Umber to give the undersides of the awnings some detail. Darken some of the reflections on the floor tiles with a mixture of Burnt Umber and Burnt Sienna. Suggest some of the trees outside with a light layer of Olive Green. Bring some of the green into the reflections on the floor tiles.

5

Begin the Darkening Process

Darken the baseboards and window trim with Burnt Umber. Add Indigo to really darken the window trim at the tops of the windows. Use Ultramarine Light to suggest the sky reflected onto the floor tiles. Add detail to the foreground reflections using Olive Green, Gamboge, Burnt Sienna and Burnt Umber while still carefully saving some whites between and on the tiles. With a heavier layer of Burnt Sienna, darken the floor between the light reflections and suggest the distant doorway. Begin to suggest some detail outside the largest window. Paint a few cast shadows on the window casing using Ultramarine Light.

6

Develop the Floor

Darken the floor with Burnt Sienna and Burnt Umber, leaving only a few grout lines lighter to suggest the tile on the shadowed right side of the painting. Once dry, wash over the area with Gamboge. This way the floor will be dark, but still have some areas of interest within the dark passages. Add some Gamboge to the reflections on the tile in the areas where the awnings would be reflected. Mix Ultramarine Light and Burnt Umber to make the color for the distant back wall. You will want the blue to be the more dominant of the two colors to suggest shadowing. Use Burnt Umber to enrich the darks on the light fixtures. Add a little more detail to the landscape outside the windows, still keeping colors pale in this area.

7

Darken the Wall to Add Drama

Lay in a wash of Ultramarine Light at the top and bottom of the wall, fading the color into the Gamboge in the middle of the wall. You are trying to create the feeling that the wall is gently lit from the fixtures and also light coming in from outside. When this is completely dry, paint a wash of Burnt Sienna over the entire interior wall, darker near the ceiling and lighter toward the floor. Using Burnt Umber and Indigo, add darks to the distant wall and doorway. Add darks to the ceiling with the same color, leaving halos of light coming from the hanging fixtures.

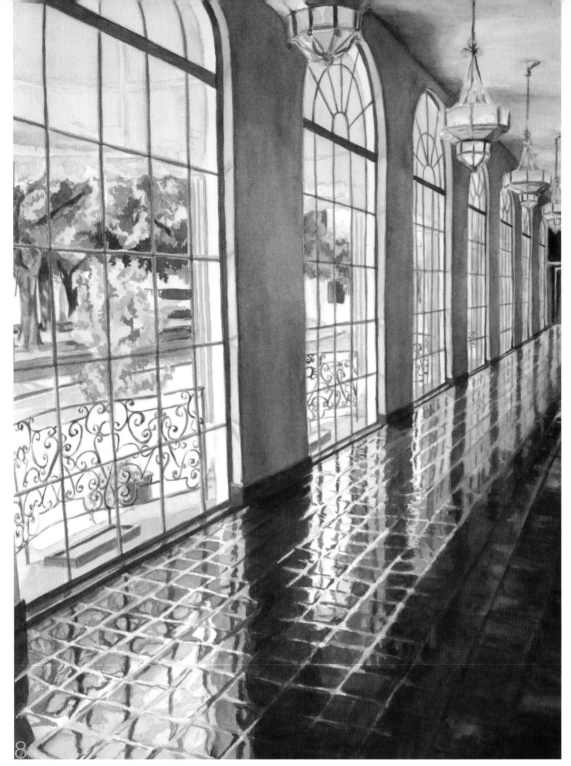

Detail the Areas Outside the Windows

While you want to be able to see what is outside, you should use slightly softer edges and keep this area a little looser than the inside of the building. Showing the outside is important because it adds another layer of visual depth to the piece, but you don't want it to become the main focus. Use a light gray wash (Indigo and Magenta) to paint the road outside and also the tree trunks. After the gray has dried, use Burnt Sienna and Gamboge on the tree trunks for added depth, and for other background detail. Paint the foliage with mixtures of Olive Green, Ultramarine Light and Gamboge. Make sure that each successive window has less detail, color and contrast outside than the one preceding it. This adds a bit of atmospheric perspective to the piece, which also contributes to the illusion of depth and increases the realistic effect.

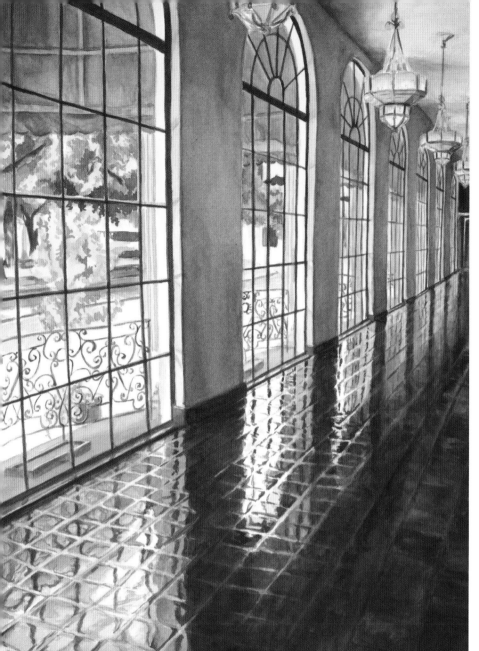

9

Play Up the Lightest Floor Reflection

Darken and add detail to the awnings with layers of Burnt Sienna, Burnt Umber and Gamboge. Do this carefully with the intent to add form, making them appear rounded to match the railings beneath. The awning closest to you should be the darkest, with each successive awning getting a bit lighter. Right now all of the saved whites on the floor tiles are the same and competing for the viewer's attention. It is best to choose one reflection to be the lightest, to draw the eye in first. The reflections cast from the first window contain a lot of interesting detail. If this area at the bottom corner of the paper remains the lightest area, you will run the risk of the viewer looking there first and then right out of the picture. I chose to leave the second window's reflections the lightest to help pull the viewer in and keep the eye moving throughout the piece. To accomplish this, tone down the whites on the entire floor except the area under the second window by applying a pale wash of Ultramarine Light.

10

Finishing Touches *(next page)*

Lay a final darkening wash of Burnt Sienna and Ultramarine Light over the interior wall. Try to make it as smooth as possible. You may want to slightly dampen the entire wall with water first to help the wash dry evenly. The wall should become darker toward the back of the room. Deepen the shadows where the wall meets the ceiling with Burnt Umber and Indigo. Add a bit more Ultramarine Light to the lighter areas of the ceiling. You can also add more Gamboge here to heighten the effect of light; however, make sure the ceiling is completely dry between layers of Ultramarine Light and Gamboge, otherwise you will turn the ceiling a rather unsightly green. Finally, using Burnt Umber and Indigo, deepen the darks on the light fixtures, baseboards, floor and window trim. At this point, you may very carefully use a small scrubber brush to clean up any rough edges. If you choose to use the scrubber, use very little water. Once you have built up rich darks, the introduction of excess water can make colors bleed and create a bigger mess.

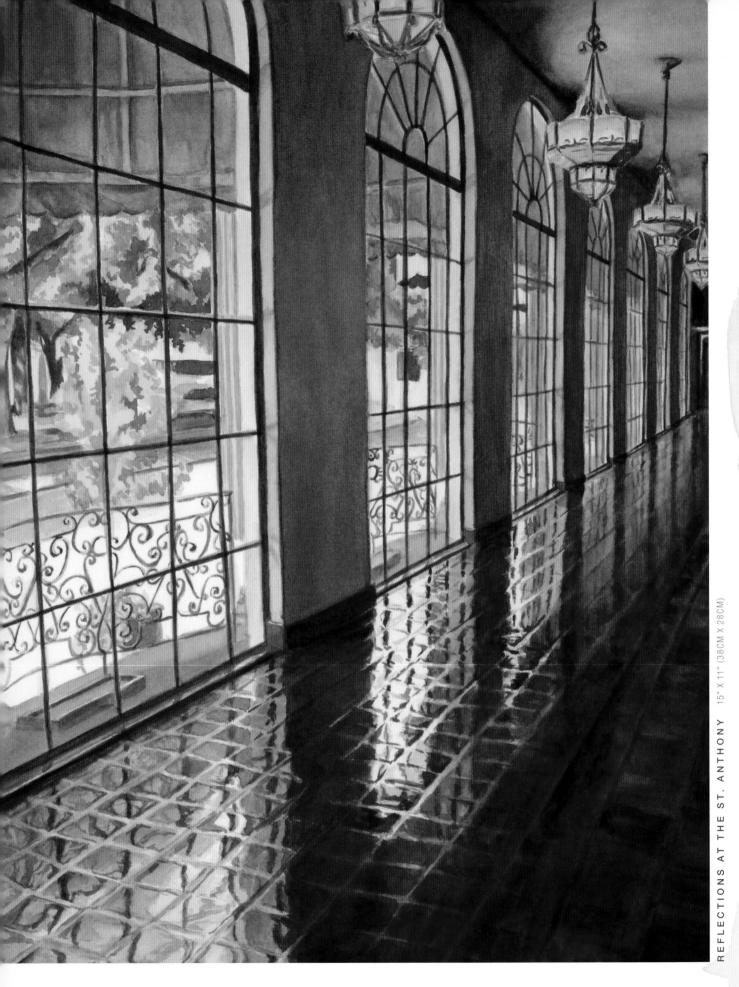

REFLECTIONS AT THE ST. ANTHONY 15" X 11" (38CM X 28CM)

before&after

This architectural piece uses linear perspective to lead the eye to the focal point. The original painting relies solely on the drawing to provide a sense of depth through perspective.

Remember to paint, not just draw, perspective.

BEFORE

The shadowed side of the building was deepened in tone to heighten the illusion of three-dimensional space.

Darks were added under the porch to make the lighter tones appear brighter.

The roadway was darkened in the distance to increase the sense of depth and draw more attention to the focal area.

AFTER

The improved painting utilizes other painting techniques, such as color and value contrast, to enhance the effects of perspective and create a greater sense of depth.

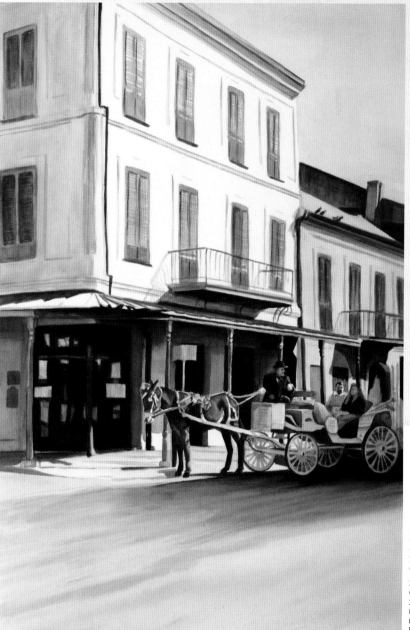

FRENCH QUARTER 22" X 15" (56CM X 38CM)

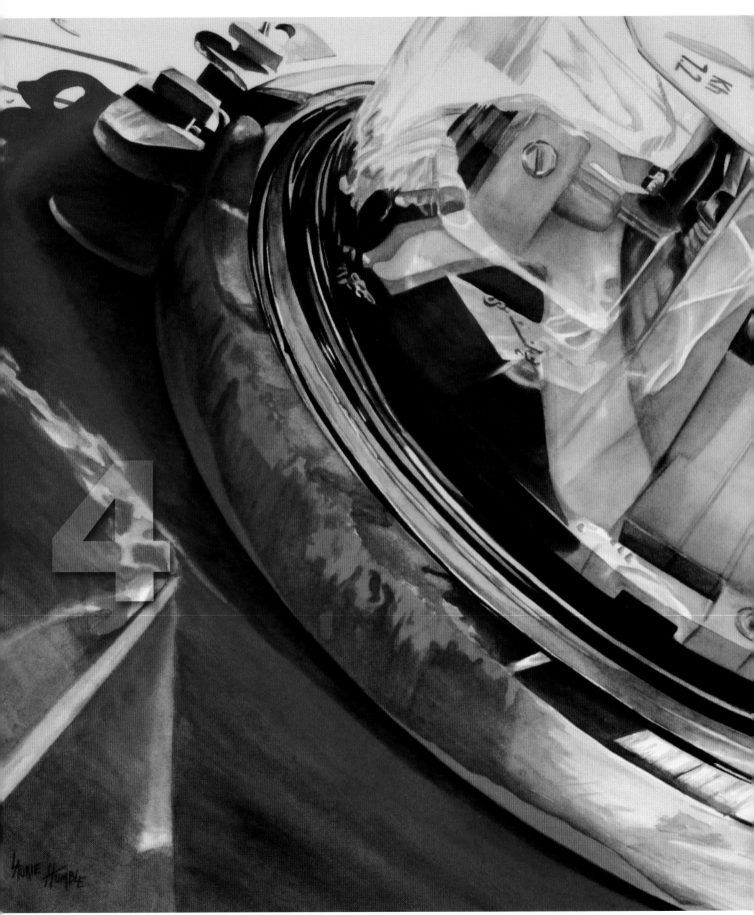

JUICE BOX 22" X 30" (56CM X 76CM)

detail

It is not the photographic quality most realists long to create; it is, in fact, the sense of depth we crave. There is a certain excitement that comes from taking a flat piece of paper and generating for the viewer the feel of three-dimensional space. In this way the artist becomes a magician who creates an astounding illusion. Just as the magician uses tricks to fool his audience, the artist must use techniques that will make the viewer see what the artist wants him to see. In this chapter you will learn how to use detail to add to the illusion of depth. Realism is an illusion as well; every item in a piece need not be depicted in graphic detail in order to appear convincing. The idea is to strengthen your focal point by playing the detailed areas against the not-so-detailed ones.

MORE THAN A METER

Almost anything can provide inspiration if you let it. While my love of realism won't let me wander off into total abstraction, it will let me have some fun. I played with light, vibrant color and an unusual vantage point to give the electric meter on my house a wild, abstract look. Most of the fine details are located in the focal area: the mechanical part of the meter. The surrounding softer edges on the top and the base help maintain the focus.

Detail the Focal Area, Not the Background

Adding detail can be one of the most profound ways to achieve more depth in your work. In general, things that are closer to us are more in focus, while things that are farther away from us tend to blur slightly. Saving crisp edges and the finest detail for your focal area will make your work look more natural. Likewise, deliberate blurring, or using less detail in the background areas, adds realism. It is helpful to include a lot of detail in the focal area of your initial drawing, and perhaps only block in larger shapes in the background.

Putting more detail in your focal area and less in your background does not mean that the background is of no importance. On the contrary, the background can be used to enhance the subject. Try to think in terms of not only layers of paint, but also layers of depth. If you can create a sense of depth in your background and a sense of depth in your foreground, imagine the effect when you put them together. The total effect is ultimately what you are striving for.

A background of any sort is preferable to none at all when it comes to creating a sense of depth, but the most effective backgrounds are those that establish a sense of place. A flat wash of color or a mottled background might look nice but won't necessarily add any depth to the work. In fact, that type of background treatment can give the appearance of a studio backdrop and rob you of the opportunity to create the illusion of a three-dimensional space. When your aim is to pull the viewer into the painting, you are better off paying as much attention to what is going on in the background as to your subject matter. Give your subject a place to be, a reason to be.

Don't Get Lost in Space

The act of simply placing your subject in an environment will give the piece more depth.

GRADUAL LESSENING OF DETAIL AND SOFTENING OF EDGES

Notice how leaves that are just out of the focal area begin to show less detail and have softer edges. The distant background shows only blurred suggestions of more foliage.

KEEPING ONLY YOUR SUBJECT IN SHARP FOCUS

The goose in the foreground and the ivy under his feet are very detailed, but even the goose just beyond him is softer and less detailed. The farther you look back into the painting, the softer the edges become. This really helps to increase the sense of depth.

TAKIN' A GANDER 22" X 30" (56CM X 76CM)

exercise
PAINTING VALUES WITH A QUARTER

To really understand what I mean by "layers of depth" try this exercise. You will need a quarter or similar large coin, a small piece of watercolor paper, and only one color. You can use any color you'd like; however, I recommend staying away from yellows for this exercise as it is more difficult to create different values with such a naturally light color.

COLORS

choose any one color from your palette

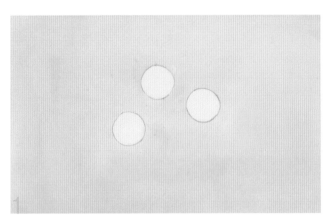

Establish Three White Circles

Use a pencil to lightly trace around your coin three separate times, making three circles that do not touch. Paint a very pale layer of your chosen color over the entire paper except for the circles, which need to remain white. You will want to use very little paint and a lot of water. Do not worry about trying to make a smooth, even wash, as it would be very difficult to do while painting around the circles. Any unevenness will be covered up by subsequent layers. Allow your paper to dry completely.

Create Four More Circles

Trace around your coin four more times. You can "underlap" at this stage if you like, drawing one coin as if it were behind another. Do not draw inside any previously drawn circle. Change your paint-to-water ratio, using slightly more paint and slightly less water than you used for the first wash. Now paint the entire background, painting around all of the circles. At no time during the course of this exercise should you ever paint in a circle, only around them. You should now have three white circles and four others with some color, all on a slightly darker background. Allow your paper to dry.

More Circles, More Values

This time draw four or so circles. Again, paint everything but the circles with a slightly darker shade of the same color. You will end up with a page full of circles that you never painted. These circles are areas of previously painted color that you have now saved. You are using the background to define the circles. You are, in a sense, using the quarter a as crutch to help you save perfect circles of color from already painted layers. Always let the paper dry completely between layers to keep your background from bleeding into your circles.

4

Circles of Depth

Now trace around your coin five times wherever you like. Paint a darker layer over the background, never painting inside a circle. This exercise can be done with many more layers than we have done here by making more subtle value changes between the layers. Another color may even be added in subsequent layers. You can actually see layers of depth forming; lighter layers come forward in the picture plane, while darker layers recede. This can be backwards, however, depending on your light conditions and perspective.

DEFINE SHAPES BY PAINTING AROUND PREVIOUS LAYERS

This technique can be used to paint complicated areas such as hair, grass and foliage, or the leaves painted here. To create depth, it is helpful think in terms of leaving layers of previously painted color, and defining shapes by painting what is behind them. I find this approach more effective than trying to think in terms of painting negative space.

Forming an Object by Painting Around It

This technique is essentially *negative space painting,* or painting the spaces around an object rather than the object itself. It is a natural thing to do when working in watercolor, since you are leaving the whites of the paper and painting in your darks.

Edge Decisions: Hard vs. Soft

Areas of detail usually refer to areas of crisp and clean, or *hard*, edges. A *soft edge* will appear slightly fuzzy or blurred. Use a hard edge anywhere you want definition, specifically in your focal area. Soft edges are great for areas of somewhat less importance. The farther away something is from the viewer, the softer the edges should be. Think of standing outside and looking off into the distance. The greater the distance, the less distinct edges become, until things appear to blur together. Approaching your painting with this in mind will help you increase the visual depth in your artwork.

Not all of the edges in your focal area need to be hard ones; it depends on what you're painting. When you apply multiple layers of color, you are painting shapes on top of shapes, on top of more shapes. Oftentimes you won't want any of the edges of new shapes you put down to be clearly visible; rather, you want them to subtly blend into the previously painted layers for a smoother appearance. For instance, when painting an apple, you might want hard edges on its outside contours but soft edges on any shapes on its surface. When painting a face, you might use hard edges for the outline of the face and around the nose, eyes or lips, with softer edges on the cheeks, forehead and chin.

There are two basic ways to create a soft edge. You can apply paint to wet or damp paper, either by brushing or dropping it in. On wet paper, color will blend together with almost no edge definition. This can create a nice effect; however, you will have little control over shapes, as the water will move the pigment around as it evaporates and dries. Painting on paper that is damp but not really wet provides nice soft edges plus a little more control over where the pigment will eventually end up. Your other choice is to paint on dry paper, immediately softening edges as you go. The latter is my preferred method. I like to have more control over the painting, making decisions about the final look of the piece rather than allowing the materials to decide for me.

To soften an edge when painting on dry paper, you will have to work fairly quickly. Once you lay down a shape, rinse your brush and roll it on an absorbent paper towel to remove most of the water. Some people find it easier to have a second brush handy just for edge softening, using this one with clean water only.

Hold your brush with the point perpendicular to the edge you want to soften, then gently feather the edge. If you stroke out and away from the edge, you will make the wash area bigger instead of just softer. To maintain the size of the shape you want to soften, use a light touch with just the tip of your brush to guide some of the pigment away from the outer edge where it tends to settle while the water is evaporating, and back into the shape you originally laid down. This does take some practice, but don't get discouraged. You will find it well worth the effort in the long run.

I occasionally paint on damp paper in background areas that I want to be very soft. What works best for one painting, or one painter, however, may not be the best choice for another. Choose the method you feel will best do the job.

HARD AND SOFT EDGES WORKING TOGETHER

The window trim and the stones on the building have harder edges; softer edges are present in the reflections on the glass and the scaffolding inside the building. Also notice the layers of very soft-edged shapes that form the face of the marble.

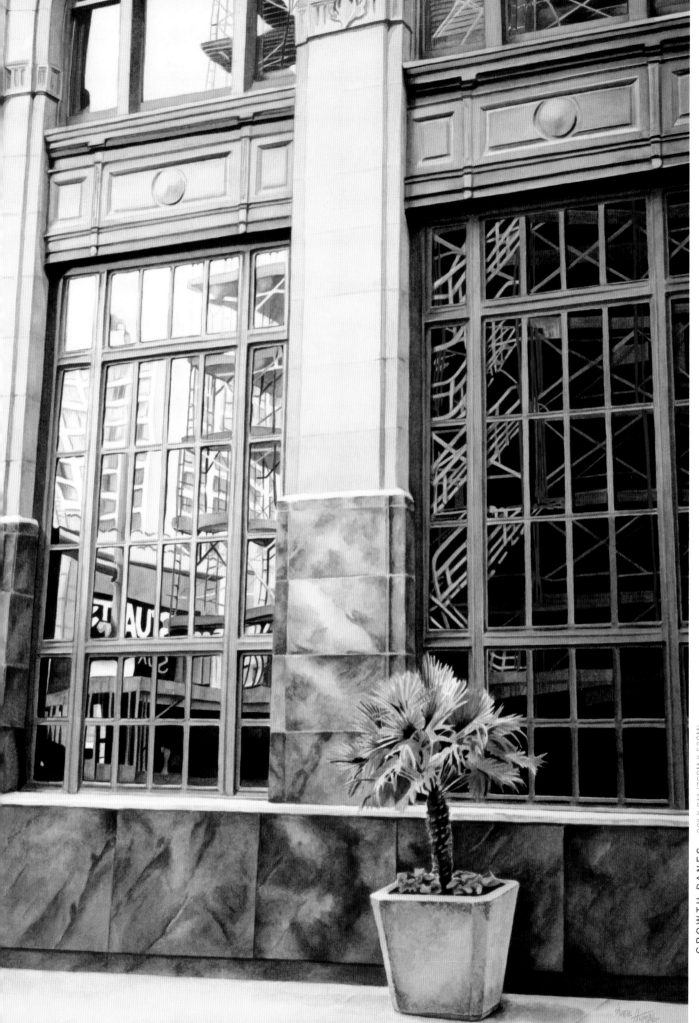

CREATING SOFT AND HARD EDGES: CLOUDS

Try painting some soft, billowy clouds to practice making hard and soft edges. Work toward deliberately creating the type of edge you want, where you want it. Start with a light drawing of some cloudlike shapes. Try using a bit of the actual sky for reference. If there are no nice clouds today, look for a photo of a cloudy sky that appeals to you. Avoid drawing a series of separate cotton-ball looking shapes. It's a natural inclination to do so, but it makes painting a realistic-looking sky extremely difficult.

COLORS

cyan
magenta

Cloud Beginnings

Paint the sky that is peeking through the clouds with a layer of Cyan. This area is farther away from you, and painting it first will make the cloud forms you paint later appear to come forward. Harder edges are all right for the clouds' top edges, but try to make softer edges on the under-sides to give them that billowy feel. Mix a light purple-gray by adding a little Magenta to some Cyan. Decide which cloud forms are closest to you and which are farther away. Use a pale wash of the purple-gray on the most distant clouds. Remain conscious of which edges you want to keep hard and which you want softer. You'll want to create more layers of visual depth, so you will need to separate the clouds from one another by making subtle value changes wherever two cloud forms touch. Clouds generally appear darker on the bottom, so you can easily darken the bottom of one cloud where it touches the top of another. Here I used a pale Cyan wash with a hard-edged top to form the top of a cloud, and faded the color softly to white into the cloud behind.

Revisit the Star Exercise

Before you try the cloud exercise you might want to practice on your star painting again. Soften a few already dried edges on some of the stars, using just clean water. Stay away from the dark areas, as the addition of water will make them bleed. Practice on edges where the star's spikes cross each other. Some colors will soften slightly, others not at all. It is good to know which of your colors you can still work with a bit after they dry. If you did more than one of these star paintings, practice on the one you don't intend to keep as a reference for color layering.

2 Give Form to the Shapes

Using your mixed purple-gray, continue to form more individual cloud shapes. Gently fade them in as you did in step 1, reserving hard edges for the top edges of the cloud shapes. Darken some of the cloud bottoms by painting a pale layer of purple-gray over the Cyan you already painted.

3 Add More Depth to the Sky

Push the most distant cloud farther back into the sky by adding a very pale layer of Magenta over much of the cloud. Use Cyan to darken and soften some of the edges and to tie the distant cloud into the background part of the sky. Continue to add more fluffy shapes, vigilantly keeping the bottom edges soft. Add light touches of Magenta to the darker areas in the clouds. This helps to make them look fuller. With Cyan, darken the background part of the sky, leaving a few cloudlike shapes of the lighter, previously painted layer of Cyan.

4 Build Shapes With Soft Edges

Using layers of both pure Cyan and mixtures of Cyan and Magenta, darken the undersides of some of the clouds, the more distant cloud forms, and the background sky between the clouds. Add more shapes, or layers of depth, for continued practice in softening edges. Work toward becoming proficient at edge softening using both methods: painting on wet or damp paper and painting on dry paper.

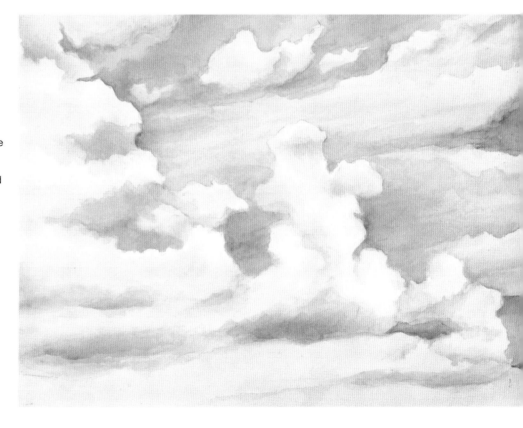

Lost and Found Edges

An edge that disappears or blends into the background or shadow area is considered a *lost edge*. Sometimes the edge of an object will be visible in one area, then perhaps disappear into a shadowed area, then reappear. This reappearance is called a *found edge*. Sometimes you can't see where an edge is going or even make out what you're looking at, both when working from photos and from life. When this occurs, it can be effective to purposely create a lost edge in your painting.

Another use for lost and found edges can arise when you want to omit unnecessary background objects when painting from photos. If these objects are large, it can be difficult to decide what to put in their place. Because they are in the background, however, these areas can usually be softened and left vague. This is often a better option than fabricating something to fill the space. A good rule to remember is: "When in doubt, fuzz it out."

HOW EDGES GUIDE THE EYE
Here all the focus is on the shiny orb and the holder's detailed hands, but the angle of the figure's arms leads you through the painting. Lost and "fuzzed out" edges on the figure and in the background keep the viewer's eye on the ball.

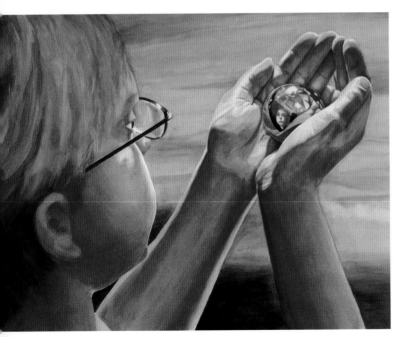

FRAGILE 22" X 30" (56CM X 76CM)

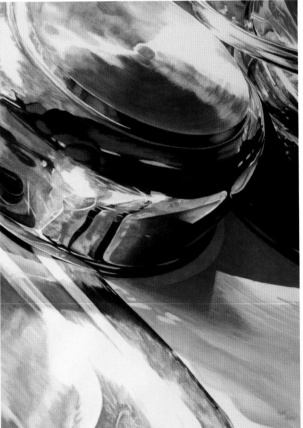

POT POURRI 30" X 22" (76CM X 56CM)

LOSING EDGES IN LIGHT AND DARK
This is one of my "realistic abstracts." I portrayed an everyday image in a new way by zooming in close and making bold color choices, giving a realistic subject—kitchen pots—an abstract feel. Here, edges are lost in both light and darkness, adding depth and interest.

DEFINING THE FOCAL AREA WITH DETAIL:
ARCHITECTURAL DECORATION

Although this sample looks very detailed overall, much of the fine detail appears in the focal area. Softer edges are used in the less important areas, and some details are merely suggested. Value contrasts and color choices also play a role in drawing the eye to the focal point, as does the perspective. The oval window is a shape that immediately pulls the viewer in because, although the arch shape is repeated, the window is the only complete oval. Concentrate on keeping sharp, hard edges in the area of the oval window, and softening the edges of other elements as you work out and away from the window.

COLORS

lemon yellow
gamboge
magenta
alizarin crimson
permanent red
cobalt turquoise
cyan
cerulean blue
ultramarine light
indigo

1

Vary the Level of Detail

Prepare a light pencil drawing, including more detail in the focal area, and only enough detail in other areas to keep you from painting over your whites. Since the perspective is important here, make sure you have it right before you start the painting process. Step back, regard your drawing carefully, and make any necessary corrections. Extra time spent to ensure that the underlying drawing is accurate will pay off in the long run. If your drawing looks off or crooked, so will the painting.

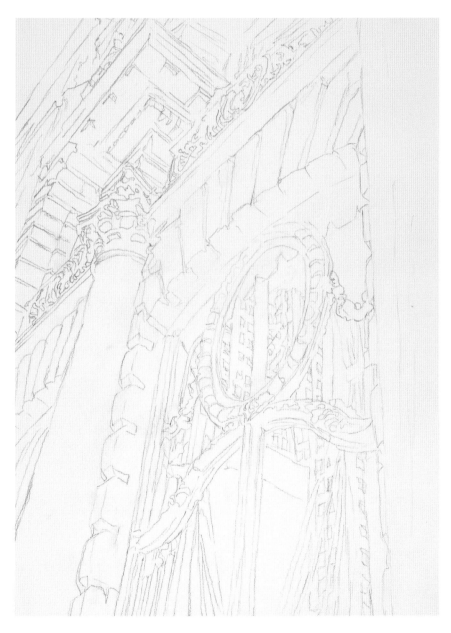

Choose Your Basic Color Palette

If you start out with very pale colors, you can more easily make changes in subsequent layers if you are not pleased with your initial color choices. I enjoy taking some artistic liberty with color, even on works of realism. You can try the colors I used or take a more traditional route. If you choose my color palette, you will be painting warm yellows and pinks on the areas where light is hitting the building, and cool blues on the shadowed areas. The window contains many reflections, and you will use both the warm and cool tones in that area. Use Gamboge and a hint of Lemon Yellow where the light is coming in, on the bricks over the window, in the window reflections and in a few touches on the column. Paint the column on the right and the top-left corner of the building with Magenta and Alizarin Crimson. Use a purple-gray mix (Magenta and Cyan) to suggest where your darker areas eventually will be.

3

Begin Building Darks

Paint pale washes of Cyan and Cobalt Turquoise on the shadowed side of the column and the undersides of the arches and window detail. Mix a yellow-orange (Gamboge and Permanent Red) to use in the window reflections and on the sunlit parts of the wall. Once that is dry, add a wash of Magenta right over the Gamboge on the bricks above the window. Paint a few dark details with Ultramarine Light and Cyan on the window trimming, the railings, the window areas which are not part of the focal point, and the stonework. Use Cyan for the reflection of sky in the window. Remember to keep edges that are not in the focal areas softer.

4

Develop Shadows and Light

Paint the little windows on the buildings that are reflected in the window with Cerulean Blue. Add some Cyan and Cerulean Blue to the shadowed side of the column and the railings. Shed a little more light on the column with a few dabs of Lemon Yellow. Apply a few washes of the yellow-orange you mixed in step 3 on the lit side of the column and the window trim. Building rich darks can take multiple layers and a bit of time. Using Indigo with a trace of Magenta, begin to darken the areas in deepest shadow such as the undersides of the column capital, eaves and arches.

5

Heighten the Contrast With Dark Details

Using your purple-gray mixture, darken the undersides of the arches, the railings and the oval window's trimming. With the same color, darken and add detail to the window reflections. Again mix Gamboge and Permanent Red and use it to paint the folds in the draperies inside the window. Add some Alizarin Crimson to the mixture and darken the window trim, the railing and eavelike areas under them, and the stonework, especially that to the right of the window. With Indigo, add dark details to the ornate window trimming, railing and stonework. It is not necessary to paint every detail, just enough to make it look as though you did. Remember that you can use less actual detail in areas away from the window, such as the railings and stonework.

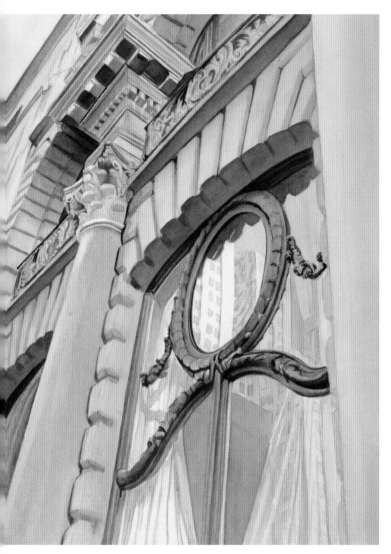

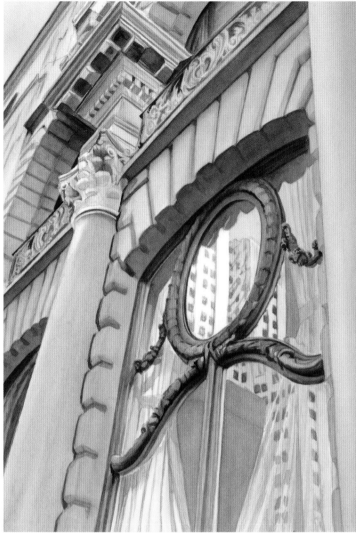

6

Bring In Blue and Continue Darkening

Slightly dampen the sky at the top-left corner and drop in a bit of watery Cyan. Use Cyan to deepen the blue reflections in the window and the shadow and folds in the draperies. Mix Cyan with Ultramarine Light and paint a light wash over many of the areas that are looking too pink, including the window trimming, the columns, the arches and eaves, and the railings. Even though you are in the darkening process and washing over larger areas to tone them down, do not forget about your white spaces. You don't want to wash over them and lose them now. The more you darken around them, the more prominent they will appear.

7

Vary the Values of Your Darks

With a mixture of Indigo and just a touch of Magenta, further darken the eaves and arches. Also darken the window trim and casings. Use Cyan to darken the sky and the reflections of it in the window. Mix Cyan with Cerulean Blue and darken the drapery folds and cast shadows. Paint the drapes and building reflections darker with the Gamboge and Permanent Red mixture you have been using. Bring a little of this color into the stonework above the window and above the column. Use Ultramarine Light and Indigo to darken the windows in the building reflections, but be careful to avoid darkening them all to the same value. Also make sure the shapes vary according to the architecture; otherwise, they will just look like a bunch of black spots.

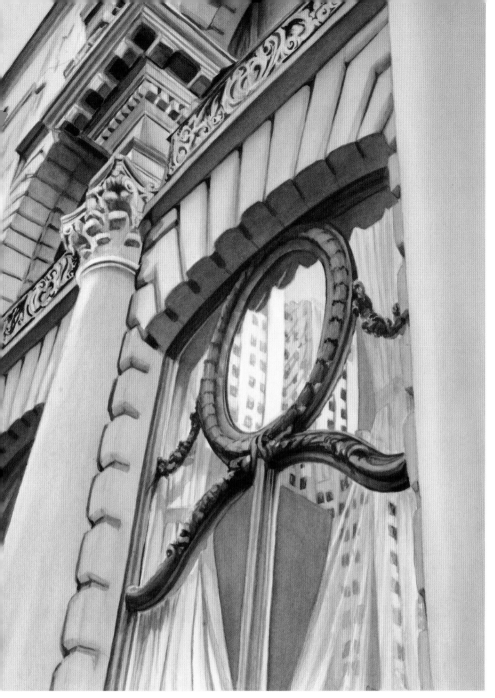

8

Add the Darkest Darks

You will paint your darkest darks during these last two steps. With your yellow-orange mixture, really darken the drapery folds and the building reflections. Use this color to tone done some of the lighter areas on the right side of the window trim, and also to add more darks to the most ornate section of the column capital. Use Indigo alone to add dark detail to the railings. Keep in mind that this detail should be just suggested and have slightly softer edges than the window area. Darken shadows and reflections within the window area using Indigo as well.

9

Finishing Touches *(next page)*

Use Indigo to really darken the shadows under the arches and eaves and the column overhang so that they appear to recede. Also darken the shadows cast by the column and the stonework. Further deepen the yellow-orange in the window, on the column carvings, above the column, and on the wall at the top left. Use Cyan to darken the sky, the arches and the window reflections. Apply separate washes of Ultramarine Light and the yellow-orange mixture, allowing them to dry in between, over the surface of the railings to tone them down and make them less prominent. You want the focus to be strongly on the oval window.

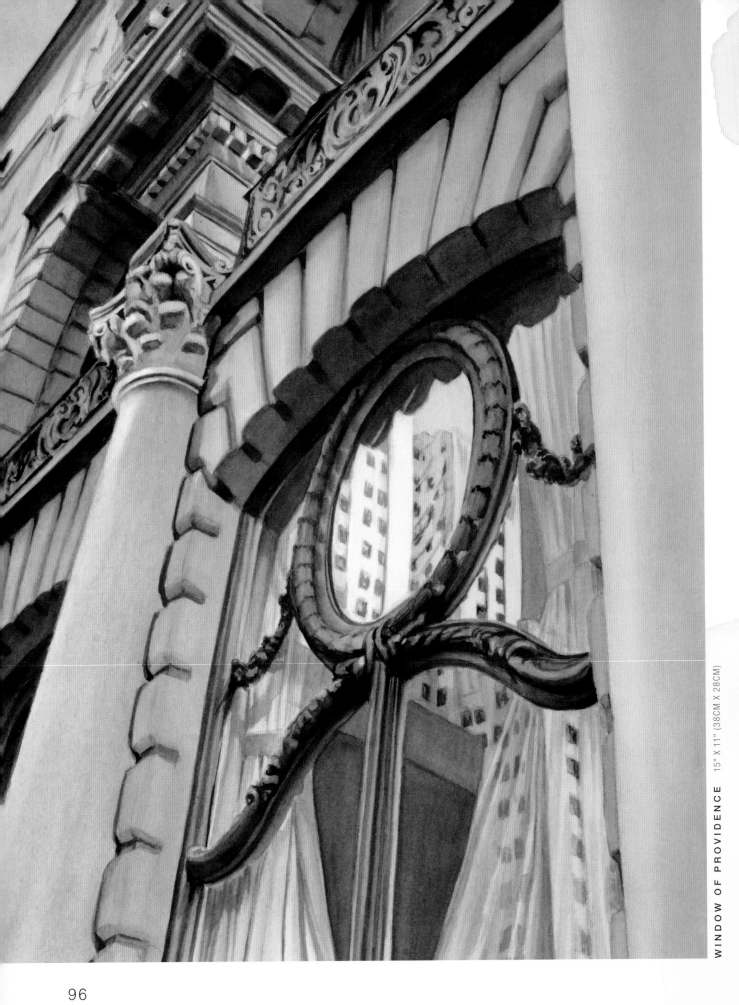

WINDOW OF PROVIDENCE 15" X 11" (38CM X 28CM)

before&after

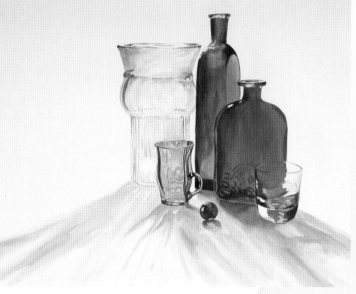

BEFORE

Always think in terms of layers of depth as well as layers of paint.

A painting that features a subject that seems to be floating in space is missing an opportunity to add another layer of depth—a background.

This painting had beautiful colors, reflections and shadows, but the subject had no place to be located.

Simple walls were added, colors were deepened, and the shadows were adjusted accordingly. Even the most minimal background clearly adds dimension.

Adding the darker wall made it necessary to deepen the shadows to balance out the composition. Notice how the darkest part of the wall on the left balances the darker shadow on the right.

The wall color had to be brought into the shadows and glass to integrate the new color throughout the painting.

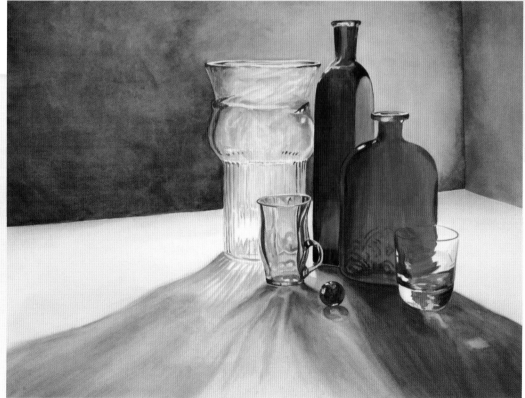

AFTER

COLORED GLASS 22" X 30" (56CM X 76CM)

97

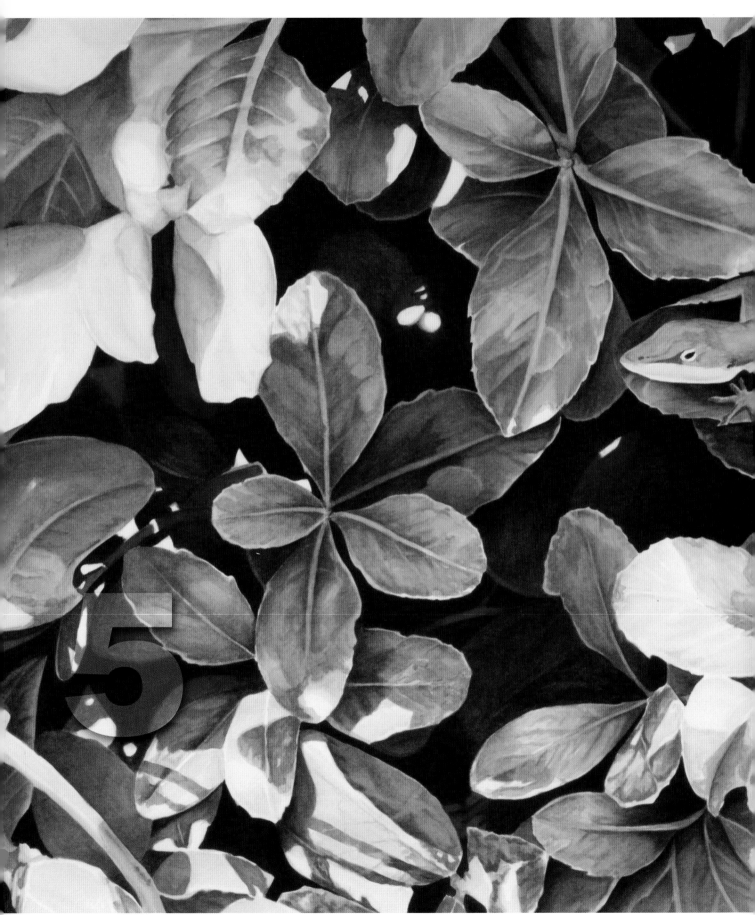

CAN YOU SEE ME NOW? 22" X 30" (56CM X 76CM)

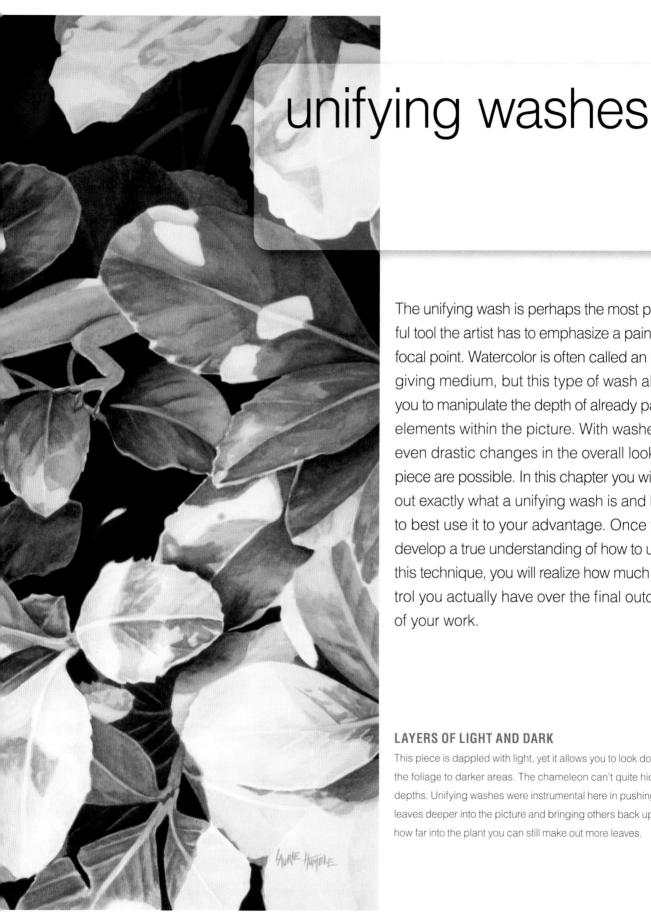

unifying washes

The unifying wash is perhaps the most powerful tool the artist has to emphasize a painting's focal point. Watercolor is often called an unforgiving medium, but this type of wash allows you to manipulate the depth of already painted elements within the picture. With washes, even drastic changes in the overall look of a piece are possible. In this chapter you will find out exactly what a unifying wash is and how to best use it to your advantage. Once you develop a true understanding of how to utilize this technique, you will realize how much control you actually have over the final outcome of your work.

LAYERS OF LIGHT AND DARK

This piece is dappled with light, yet it allows you to look down into the foliage to darker areas. The chameleon can't quite hide in its depths. Unifying washes were instrumental here in pushing some leaves deeper into the picture and bringing others back up. Notice how far into the plant you can still make out more leaves.

Pushing Back and Pulling Forward

An effective way to achieve added depth in any painting is to concentrate on pushing some areas back while pulling other areas forward. It is surprising how easily this can be accomplished with watercolor. The painting process itself—of starting with the lightest lights, then adding the midtones and gradually layering to the darkest darks—causes the darks to recede into the background and the lights to "pop" into the foreground. The unifying wash increases this effect and thus increases the illusion of deep, three-dimensional space.

A *unifying wash* is simply a wash of color put right over several already painted areas, tying them together. It is an easy and extremely effective technique that actually has a number of applications. Unifying washes can be used to enhance the effects of value contrast, color saturation, perspective and detail to strengthen the focal point.

Larger unifying washes work well when you are nearing the end of the painting process. Look at your work from a distance. Are too many areas in the painting competing for your attention? If so, apply a wash over areas of lesser importance. This will tone down the contrast, visually pushing those areas back and away from the intended focal point.

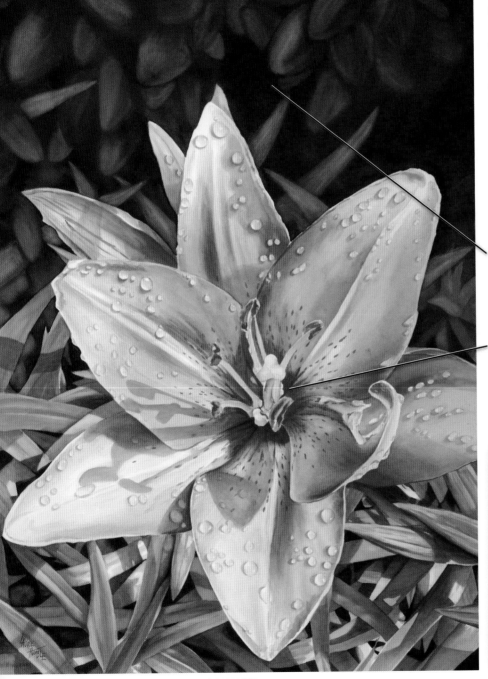

A large unifying wash over the top of the piece pushes the most distant area of the scene even further into the background.

Smaller washes behind the detail in the flower's center make this feature come forward.

Push and Pull Go Hand in Hand

In short, larger unifying washes are intended to push an area back, or make it appear to recede. The inevitable outcome of this is that the other areas seem to be pulled forward.

IN THE PINK 30" X 22" (76CM X 56CM)

Since saving whites is so important in watercolor, sometimes the fear of not saving enough white spaces can cause you to save too many. It is always better, however, to save too many than not enough. Lost whites are gone, but any white spaces that are too prominent in the end can always be toned down with a unifying wash. If you want to reserve your area of highest contrast for your focal point, you can ever so slightly tone down the contrast in other saved white areas.

If you are using color saturation to bring out your focal point, unifying washes can be used to mute color in background areas. If you are trying to create depth with perspective, the use of multiple unifying washes can enhance the effect by visually pushing areas back toward a vanishing point. If you are using detail to accentuate your focal point, unifying washes will help to further soften edges in the other areas.

The shadows were created with unifying washes.

Washes were used to push back areas of the distant bills and background.

THE ROOT OF ALL EVIL 30" X 22" (76CM X 56CM)

CREATING CRUMPLES AND FOLDS

Many small unifying washes were used here to give the effect of crumpled bills. In some places, a wash was applied over an entire bill or coin to push it back.

Color Choices

Once you decide to use a unifying wash, you must choose a color for it. Since the purpose of your wash is to tie areas together, choose the color carefully. To push a too-prominent area back to join the background, opt for a light wash of a color that is already dominant in the background area. Avoid bringing in a new or foreign color, or using a color that is not prevalent in the background, as this will cause the area to stand out rather than recede.

Using a cool blue already predominant in the background, I laid a wash over all the figures outside the focal area to push them into the background.

PLAYING DOWN DISTRACTIONS

The background of this piece was competing with the foreground, causing the focal area to get lost. One large unifying wash was all it took to bring the focus back were I wanted it. I used cool tones for the wash so the warmer tones of the more important foreground figures would stand out.

STRINGS ATTACHED 30" X 22" (76CM X 56CM)

PUSH AND PULL STARS

Find your star exercise once again. It should be dry and ready to practice on one last time. This time you will use unifying washes to change the look and the focal point. Begin by using clean water to paint over the large red star that is now the focal point, and dab off as much of the color as you can with a paper towel. If your piece has a small star on it from the perspective exercise, lighten this star as well. Again, if you are saving one of these paintings for color reference, use the one you don't intend to keep.

COLORS

lemon yellow
alizarin crimson
permanent red
cyan

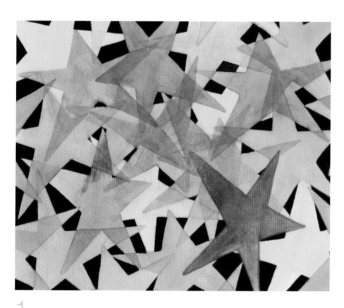

1

Unify All but the Focal Point

Once the darker stars are as light as you can get them and the piece is completely dry, choose a different star to make your new focal point. Try to choose one that has not gotten too dull with layers of complementary colors. Paint a large unifying wash of Lemon Yellow over all of the stars except the new focal point star. Try to stay away from the dark areas to avoid making them bleeding back into the wet stars.

A Multimedia Technique

Unifying washes can be accomplished with most painting mediums, when the paint is properly thinned to a transparent consistency. I have used this technique with acrylic, oil and gouache.

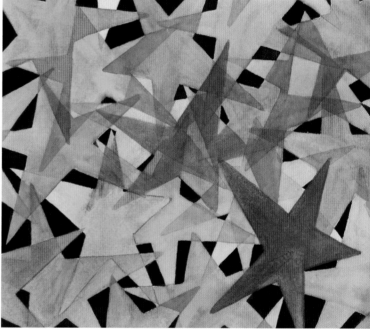

2

Make the New Focal Point More Prominent

Paint a few stars a color similar to that of the old focal point to help tie it in with the background (I used layers of Permanent Red and Alizarin Crimson). Next, use a few more unifying washes to push the other stars back and away from the new focal point. I washed over many of the stars, staying away from the ones I just added reds to, with a pale layer of Cyan. Be sure to darken the stars directly around the new focal point star. It now stands out because it is lighter and brighter than the others, having fewer layers of paint.

Separation of Elements

Separation of elements is perhaps the most important concept I can impart to you in terms of creating the illusion of depth. When looking at your initial line drawing, consider every line as being a separation between two planes. The space on one side of a line is probably either slightly in front of or slightly behind the space on the other side of the line. In other words, anywhere two objects meet, there should be some change in tonal value. If there is no change in value, there probably is no need to draw a line. A gentle gradated wash along the edge where one object meets another will visually separate the two objects. The greater the separation, the greater the feeling of depth you will create.

The more objects you can separate, or the more planes you can establish, the more effective the picture's illusion of depth will be.

Avoid leaning on your original drawing to separate elements. A line drawing is inherently flat, even if it has great perspective. Shading, shadows, color and value contrast are what give a painting a real sense of depth. When you feel your painting is finished, check all of your originally drawn lines to see if you have a value change at each one. If you don't, you are missing an opportunity to increase the depth of the piece.

Drawings Don't Ensure the Illusion of Depth

Don't rely on your line drawing to separate elements and establish different planes. When you erase what is left of your original drawing, you should have value changes where lines used to be.

PAINT INSIDE THE BOX

This is one of my most complicated paintings. The separation of elements was essential for it to impart any sense of depth. I imagined the paper as a deep box with many layers inside. Every twig had to be in front of or behind another; sometimes far behind or well in front. See how three-dimensional this piece looks? A very distant, softer background visible between the twigs heightens the illusion.

EARLY BIRDS 30" X 22" (76CM X 56CM)

SEPARATE RIBBONS

This exercise will help you see a subject in terms of which parts come forward and which recede. You'll use small washes in various values to visually separate the ribbons wherever they cross, as well as practice softening edges while painting on dry paper.

COLORS

choose several from your palette

1

Draw the Ribbons

Attach two pencils to each other with rubber bands, placing a piece of sponge between them so that the pencil points are about ¾" (2cm) apart. Holding the pencils vertically, practice drawing one long ribbon that crosses and overlaps itself. Once you have the hang of it, draw several on a piece of watercolor paper. Decide which parts of each ribbon are in front and which go behind, and adjust your drawing accordingly. The two lines that make up each ribbon have been attached to each other at every turn to form the ribbon shape.

Paint Only One Side of Each Ribbon

Paint the side of the ribbon that faces you first. Paint the ribbon with little gradated washes, so that it appears to recede and then come forward according to the way it is drawn. Go darker as the ribbon goes back or behind; lighter as it comes forward. Pay careful attention to edges where the ribbon crosses over itself; this is where you are separating elements. Practice hard and soft edges as well, reserving hard edges for the outside edges of the ribbon and keeping the value changes on the ribbon surface very soft.

3

Paint the Other Side

Paint the undersides of the ribbons in the same manner. To further darken an underside, add a bit of color from a neighboring ribbon.

Defining With Washes, Not Outlines

The edge of one object can be used to define the edge of another. You don't have to paint around every edge of every object. By painting the edge of one object you can simultaneously create the edge of the object it is touching. For example, if you are painting a subject in bright light and its outer edge should be white, resist the urge to paint a thin line around it to show an edge. That would appear as an outline, and flatten the piece. Instead, use the background to define your white edge by painting just up to the edge and stopping where the white should begin.

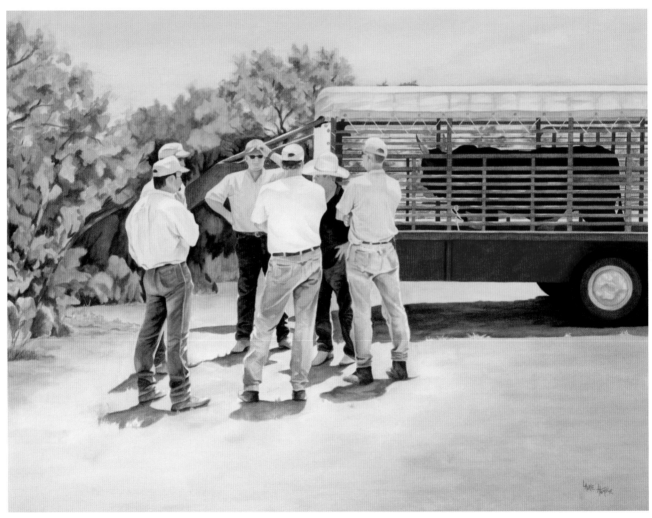

BULL SESSION 22" X 30" (56CM X 76CM)

LEAVING LINES BEHIND

Make a habit of using one edge to define another, as this will help to keep you from outlining—the death knell for the illusion of depth. Notice how the background and surrounding objects are used to define the edges of the whites in this painting: the shirts, hats and trailer cover. Very subtle washes of color separate white from white, not painted lines that would instantly flatten the work.

SEPARATING ELEMENTS: MATCHSTICKS

In this exercise you will practice separating elements and using unifying washes. You can work from my drawing or set up your own pile of matches. If you choose to use your own setup, make sure you place your matches where you won't knock them over before you're finished painting them. Keep in mind that your lighting conditions and shadows will be different from those in my example. Follow what you see in your own setup whenever possible.

COLORS

gamboge
alizarin crimson
permanent red
burnt sienna
cyan
ultramarine light

1
Make a Simple Line Drawing

Make sure your drawing fills your watercolor paper and that several matches go off the page; this will make it easier to paint later. Don't worry too much about small details. Draw the top match first. Next draw the match directly under the first, and continue with the other matches in this manner. Starting at the top layer and working down will help you keep erasing to a minimum.

2
Lay In a Pale Underpainting

Begin with very pale layers of Gamboge, painting the shadowed top side of the matches. Leave the sides facing you much lighter until later. Paint a pale undercoat of Permanent Red mixed with Alizarin Crimson on the match heads, leaving the very tips as the white of the paper. In this step you should lightly block in your colors so you can check your color choices. If you aren't happy with the way it looks, you can make color changes in successive layers. Paint lightly around your whites so it's less likely that you'll accidentally paint over them later.

Visually Separate the Matches

Every place that one match crosses another, change the tonal value. Add some color to the lighter sides of the matches toward the bottom of the stack, using Gamboge and a little Burnt Sienna. This will make the bottom matches begin to recede into the picture. Using Burnt Sienna, begin to darken the shadowed edges that are the deepest in the stack. When that layer is dry, continue darkening slowly by bringing in some Ultramarine Light on the shadow sides and where the top sides cross under other matches.

Push Back, Pull Forward

With individual layers of Gamboge, Burnt Sienna and Ultramarine Light, continue darkening and further separating the matches. Look for, and add, shadows cast onto the matches themselves. The more you darken and separate the underlying matches, the farther they will recede. By increasing the value contrast this way, you push back the matches on the bottom while simultaneously popping out the uppermost matches.

Add Soft Shadows and Touch Up Edges

Using Ultramarine Light with just a touch of Burnt Sienna, lay in the soft shadows cast by the matches onto the ground, softening edges as you paint. Paint a few soft shadows on the ground using Alizarin Crimson under the match heads. Most shadows, upon close inspection, reflect a bit of the color of the object that casts them.

Touch up any sloppy edges on the uppermost matches, making sure edges are well defined. Gradually soften edges of the matches farther down in the stack by gently going over the edges with a clean, damp brush. Lay unifying washes of Cyan and a little Ultramarine Light right over the bottom matches and the background, gently fading the color into the background. This will tie the match stack down to the ground. It will also soften background edges, decrease contrast and increase the overall feeling of depth.

Apply Finishing Touches

Lay in a pale Cyan background, using the color to define the match tips. Since your initial drawing had several matches going off the paper, the background washes can be applied in small sections. Paint the background color, in the form of a unifying wash, right over (or bring into) the lowest matches, wherever you feel the piece could use even more depth. Last, darken the shadows cast by the matches. Shadows should be darkest nearest the object that casts them, then fade out a little.

UNIFYING WASHES: FLORAL

Unifying washes can be the most effective way to increase the visual depth of a painting. The effect is also one of the most effortless to accomplish. With this floral composition, you'll practice using unifying washes to achieve greater depth by pushing some areas into the background and pulling other areas forward. This push-and-pull effect will reinforce your center of interest—the closest geranium blooms—and give the work a three-dimensional feel.

COLORS

lemon yellow
gamboge
magenta
alizarin crimson
permanent red
olive green
cinnabar green light
cyan
ultramarine light
indigo

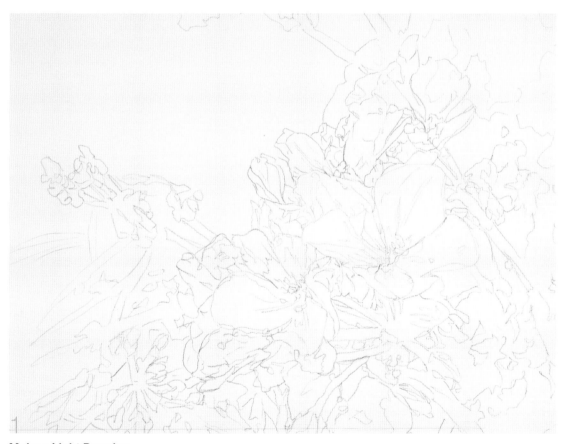

Make a Light Drawing

Draw shapes around white areas throughout the painting. Draw the most detail in the focal area, indicating just the larger shapes and bright white areas in the background. Notice how the drawing was designed to break up the page, with elements extending beyond the edge of the paper. This divides the background into sections, making it easier to lay in background color.

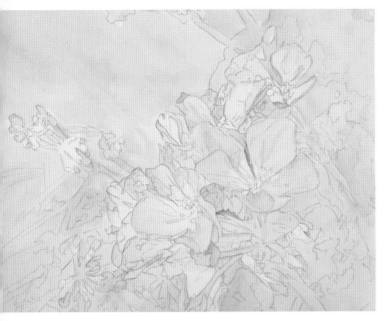

Lightly Block In the Colors

Paint pink tones on the flower petals with Alizarin Crimson. Paint any slightly darker pinks with Magenta, which makes a pale fuchsia when watered down. Reds that look more orangish or peachy can be made with Permanent Red. Put some Magenta on the flower buds, always mindful of areas that need to remain white or very light. Using Olive Green and Gamboge, paint the lighter areas of the background. Paint the remaining background areas Olive Green. Paint right over any leaves and stems you have drawn, but don't paint over white areas you need to preserve. You have essentially started using the unifying washes by painting over the background with green; you've begun to tie the leaves and stems more to the background and less to the foreground. You've also begun separating the flowers from the leaves.

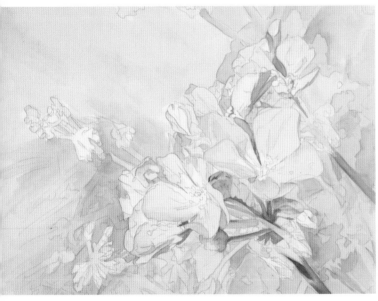

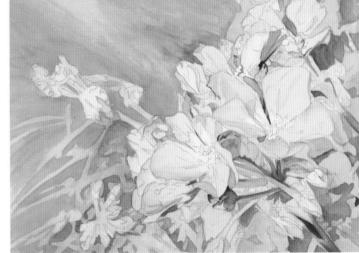

3

Add More Tones

Use Alizarin Crimson to paint a few suggestions of more buds in the background. Lay a unifying Olive Green wash on the bottom left, leaving some areas alone. Review the quarter exercise on page 84 and use the same principle to paint around a few stems and buds, allowing them to appear lighter so they will visually come forward. Also suggest some of the other dark areas with Olive Green. Use a mixture of Cyan and Cinnabar Green Light to brighten some of the leaves behind and under the flowers. Paint a somewhat heavier layer of Olive Green on the darkest parts of the flower stems. Combine Magenta and Cyan for a purple-gray, and use it for the darkest areas on the flowers. Paint midtone detail on the flowers with Permanent Red.

4

Develop the Darks

To bring the flowers forward and away from the background and leaves, begin to darken the background by painting it with a wash of Indigo. As you work, leave some stems unpainted, so that they remain the Olive Green of the previous layer. Notice how this wash increases the illusion of depth. Paint a few dark reds using Alizarin Crimson with a bit of Ultramarine Light added.

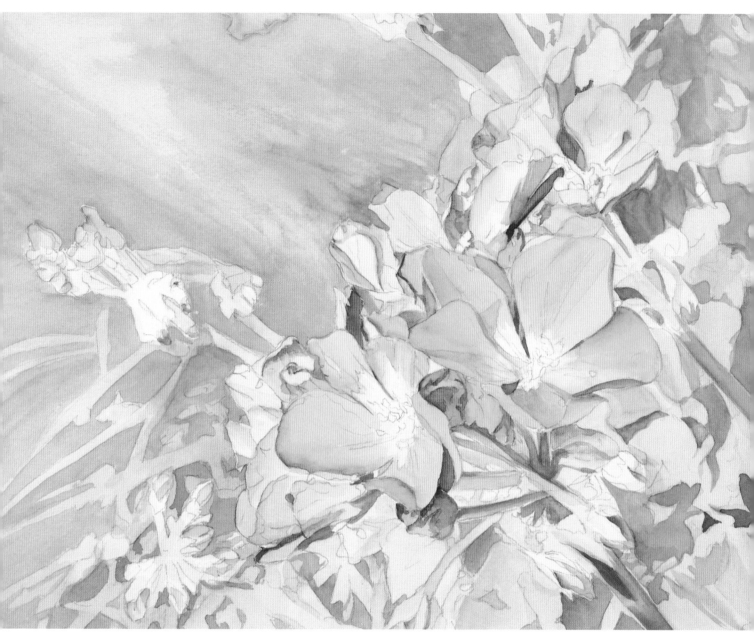

5

Start Separating

Although you are working on unifying washes, don't forget the other techniques you've learned. Use soft edges on the shapes within the petal faces and in the background, and harder ones on the edges of the petals and some of the stems.

Now concentrate on visually separating the elements of the piece: the background from the leaves, the leaves from the stems and flowers, the flowers from each other, and one petal from the next. Use Permanent Red to add the brightest areas on the flowers and some of the buds. Paint shadows and pale washes along petal edges to separate them, pushing some back and pulling some forward. Make sure the petals you choose to darken and push back coincide with your drawing. You don't want to push back a petal that you have drawn to be in front of all the others. Do this carefully, fading the washes so you don't create an outlined look.

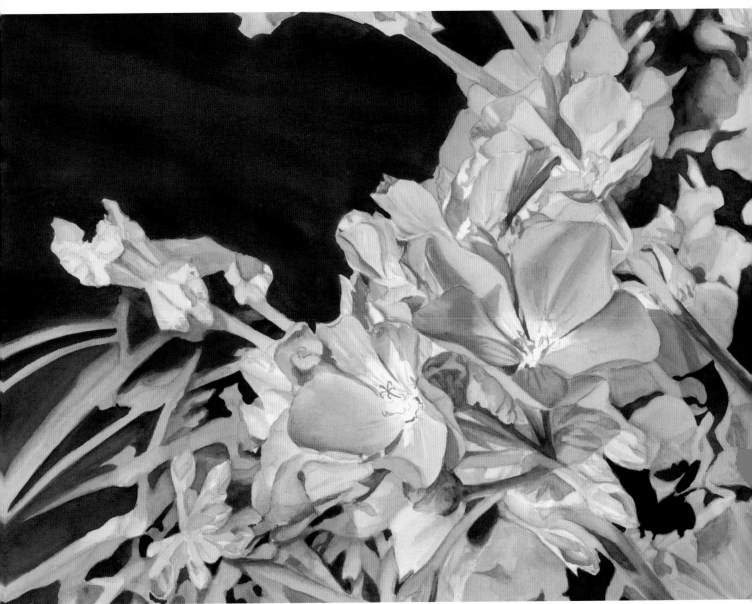

6

Introduce Vibrant Color

Continue to separate the flowers from each other, as well as separating each individual petal. Use only the colors you've used in the flowers thus far: your three reds, Cyan and Ultramarine Light. Use the blues very sparingly to avoid making the flowers look too purple. Begin to suggest more detail in the folds of each petal, and the shadows cast on and by the flower petals. Paint some detail in the flower centers and the buds. At this stage, the flowers might look too dark, but you need that vibrant color or the flowers will appear pale and flat. Just don't paint over all your whites, and maintain a variety of values for contrast. As you darken the rest of the piece in subsequent steps, the flowers will look lighter again in comparison.

7

Begin to Separate the Leaves

Paint a Lemon Yellow wash over the stems and leaves that have a lot of light on them. Fade edges softly into the background. Use pale Alizarin Crimson to lay in some shadows cast by the flowers on the leaves. In some areas on the bottom left, under the flowers, and on the top right, behind them, push back the leaves a little and tie them into the background by painting pale Alizarin Crimson over any existing paint work. Paint some leaf detail with Olive Green, keeping the edges soft. With your greens, blues and yellows, mix a few more shades of green and continue separating elements and adding depth, applying several layers of washes to give the leaves a realistic look. Make a value change anywhere you've drawn a line, or where two items cross or touch. Decide which is in front, which is behind, and paint a mini unifying wash to separate them. Mix Ultramarine Light into Olive Green and add the darkest darks on the stems and leaves.

8

Darken the Background

To make the flowers pop out, increase the contrast by greatly darkening the background. For this, squeeze out a lot of fresh Indigo and mix it with a little Magenta for a deep violet that fits the color scheme. Paint the largest background area first. Dampen the paper with clean water, brushing it carefully around the flower edges, so the pigment will flow only to where you applied water, leaving nice, clean edges. I like to leave some variation in the wash because a very flat wash looks as it sounds: flat. With your brush, guide the paint in the diagonal direction the flowers are growing, making the composition more interesting. Paint the rest of the background, including any spaces showing between the leaves. Push back some of the leaves and stems that are the farthest away from you by painting over them with a pale wash of the Indigo/Magenta mixture, unifying them further with the background.

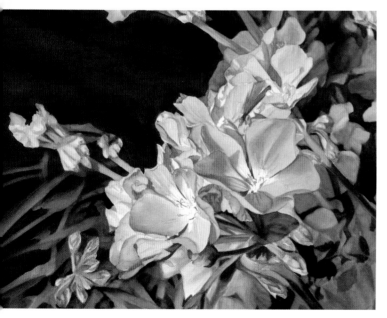

9

Use Unifying Washes to Tie Areas Together

Choose a color other than the background color, one already prominent in the piece that will make sense in each area you want to unify. Tie some of the far stems and leaves together, but don't let them fade entirely into the dark; they should appear to be merely in shadow. The flowers cast these shadows, so use Alizarin Crimson for unifying washes and to deepen the strongest shadows in this area. Darken and add a bit more detail to the buds, but use soft edges as they are in a less important area. With your greens, continue to add soft-edged detail to the leaves and stems. Apply a pale Indigo wash over any leaf or stem part that you want to recede into the background more fully. Paint the darkest darks on the stems and leaves Olive Green mixed with some Indigo.

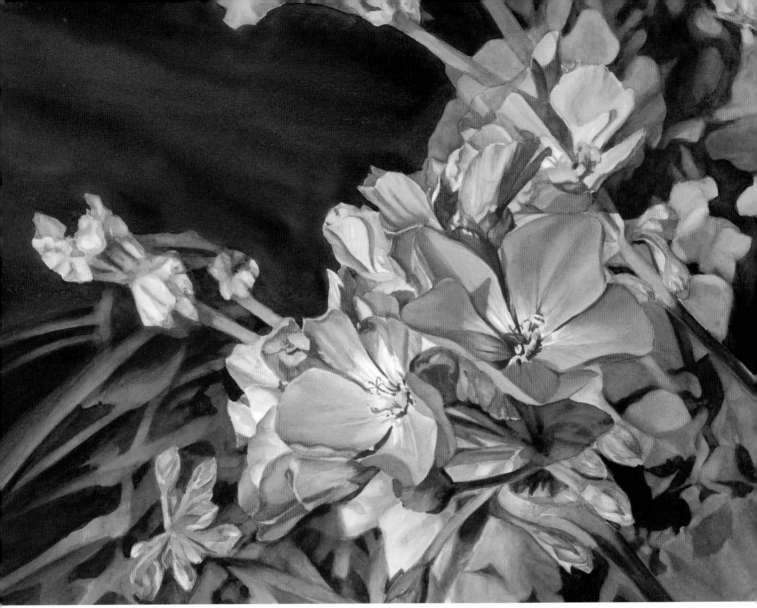

10

Finishing Touches

The use of multiple unifying washes in the background helps to keep those edges softer, the colors more muted, and the contrast toned down. This allows the focal point, the flowers, to stand out. At one point the flowers almost looked too dark, but now that the deepened background is complete, notice how pale the flowers seem. All that is necessary to perfect this piece is to brighten the flowers, while adding some hard-edged detail. Using the same colors you used for the flowers, further separate the petals and deepen the color. Avoid just darkening shapes from the previous layers. Instead, try to make new shapes, leaving shades from previous layers visible, as in the quarter exercise on page 84. Keep in mind that every visible layer of tonal value creates another layer of visual depth. The more you deepen the colors in the darker parts of the flowers, the brighter your whites will appear. Mix a touch of Indigo into Alizarin Crimson and paint the darkest darks of the flowers. Use the mixture to add the final details to the flower centers.

Revitalize Earlier Works

Rework any previous pieces that you're dissatisfied with by adding some unifying washes to increase the sense of depth.

before&after

BEFORE

All the basics were present here, but it was still possible to improve the painting by adding depth. The figures were not easily distinguishable, and the land in the background did not have much dimension.

See your picture as a deep box: push some areas back into the box and pull others forward.

Washes were painted over the water, darkening it as it recedes into the background.

The darker water helps to visually pull the figures into the foreground.

Many small unifying washes were employed to tie together areas of rocks and foliage, differentiating between the various planes within the picture.

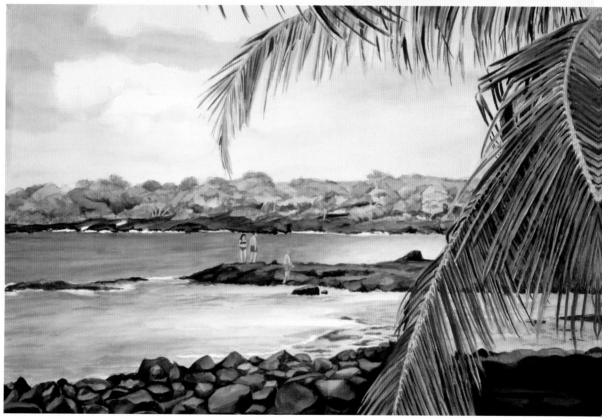

AFTER

ON THE ROCKS 15" X 22" (38CM X 56CM)

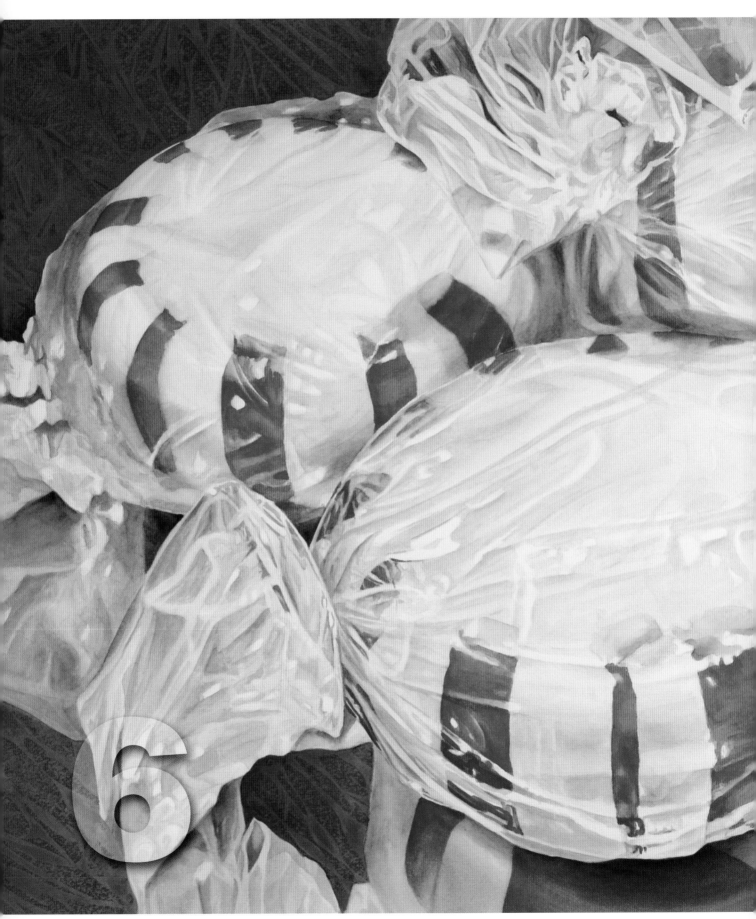

AFTER DINNER 22" X 30" (56CM X 76CM)

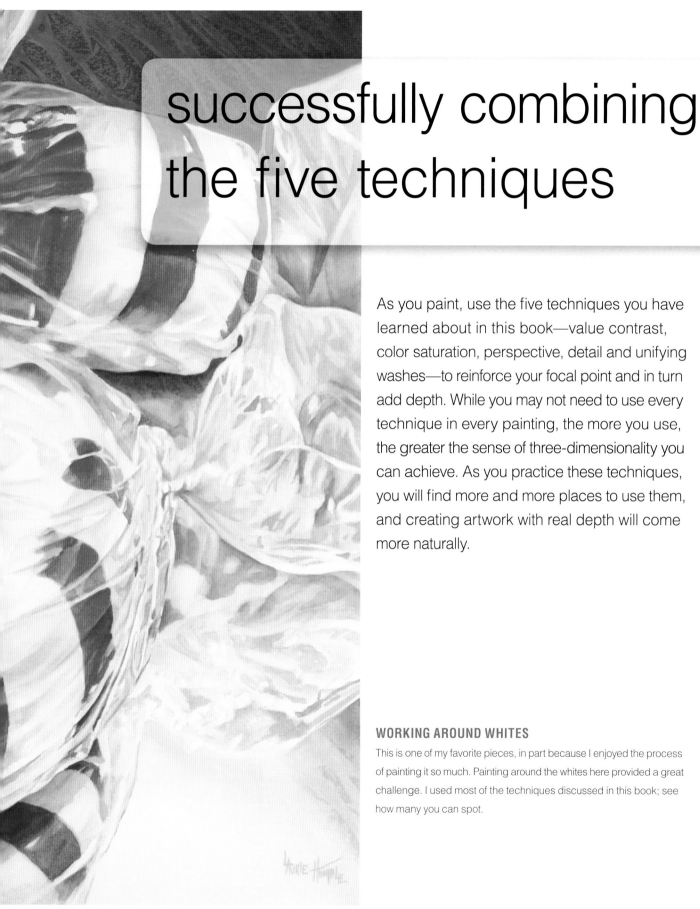

successfully combining the five techniques

As you paint, use the five techniques you have learned about in this book—value contrast, color saturation, perspective, detail and unifying washes—to reinforce your focal point and in turn add depth. While you may not need to use every technique in every painting, the more you use, the greater the sense of three-dimensionality you can achieve. As you practice these techniques, you will find more and more places to use them, and creating artwork with real depth will come more naturally.

WORKING AROUND WHITES

This is one of my favorite pieces, in part because I enjoyed the process of painting it so much. Painting around the whites here provided a great challenge. I used most of the techniques discussed in this book; see how many you can spot.

Tying It All Together

No matter what subject you choose to paint or what style you choose to paint in, from realistic to abstract, you can create a greater sense of depth. Always, *always* make sure you have a clear focal point. Then remember the five key ways to strengthen it and increase depth.

Using of any of these concepts alone or in combination will effectively increase the sense of depth in your work. Keep these concepts in mind as you work so they will become second nature to you. You will find that you'll begin to use them all in varying degrees in every painting you do.

Try reworking an older piece or two that have always appeared too flat to you. Use this checklist to look for possible changes you can make.

- Make sure you have a clear focal point, or create one.
- Boost the value contrast wherever possible. Make sure the tone of your work is not too pale.
- Enhance color. Add color to any dull shadow areas. Intensify colors in your focal point and mute background colors.
- Integrate any color that looks foreign by adding a little more of it throughout the painting.
- Soften edges in less important areas. Make sure you have both hard and soft edges throughout the piece.
- Make sure all elements appear to be viewed from the same vantage point, and that there are some elements that guide the eye to your focal point.

- Check for any elements that could be visually separated from one another with a gradated wash.
- Use unifying washes to push less important areas back and pull your focal point forward.
- Tone down any areas outside of your focal point that appear too prominent.
- Eliminate outlines. Use the edges of surrounding shapes to define objects instead.

See how many of these techniques you can use to improve your earlier work. Once you see how much more depth and realism you can achieve in an old piece, just imagine what you will be able to create when you use these concepts right from the start.

5 techniques to increase depth&realism

value contrast
color saturation
perspective
detail
unifying washes

THE FIVE TECHNIQUES AT WORK

This portrait of my daughter captures her at a moment when she was deep in thought, unaware that anyone was watching. The piece has a lot of value contrast. The red, as well as each color repeated throughout the piece, draws the viewer in and up to the face. Harder edges are used near the face and softer edges are employed everywhere else. Subtle perspective is present as well; the lines of the figure lead the eye deeper into the into the scene, and the shadows cast upon the body help to draw attention toward the face. And, as always, unifying washes push some areas back while pulling others forward.

UNDER THE LATTICE 30" X 22" (76CM X 56CM)

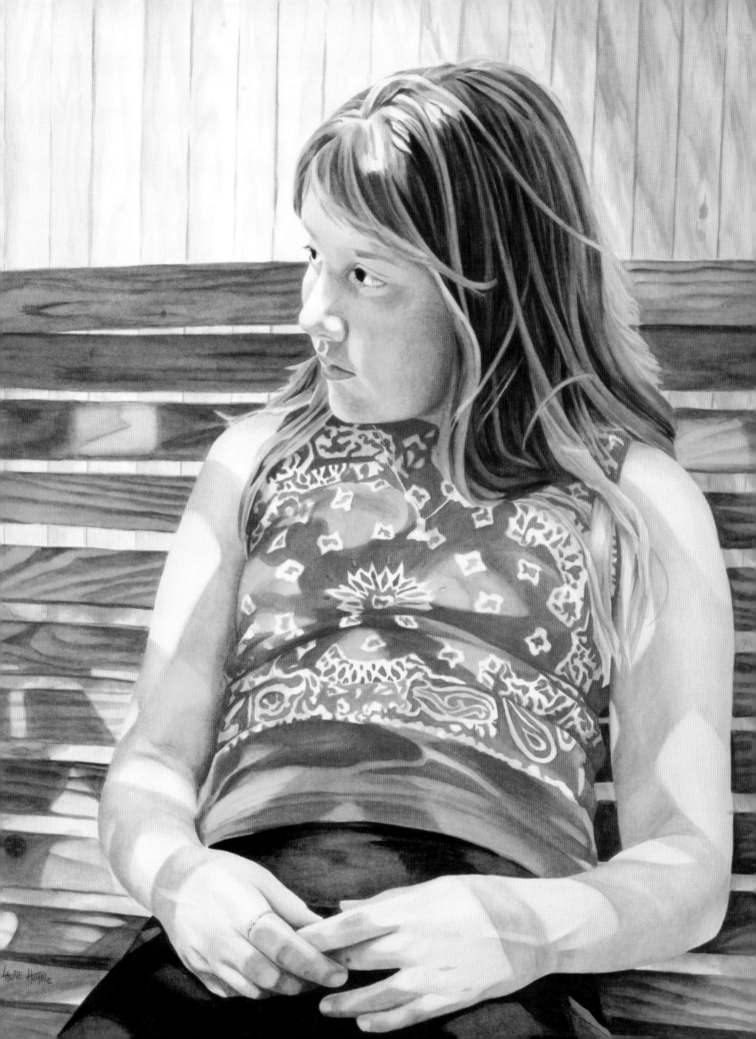

FIVE TECHNIQUES FOR MAXIMUM EFFECT

In this painting of a stop along San Antonio's famous River Walk, you will utilize all of the techniques discussed in the book to create a piece with a strong focal point and a great sense of depth. One-point perspective draws the viewer in. High value contrast, color saturation, detail and unifying washes combine to increase the effect. You will use all of the colors in our palette for this vibrant piece.

COLORS

lemon yellow
gamboge
magenta
alizarin crimson
permanent red
burnt sienna
burnt umber
olive green
cinnabar green light
cobalt turquoise
cyan
cerulean blue
ultramarine light
indigo

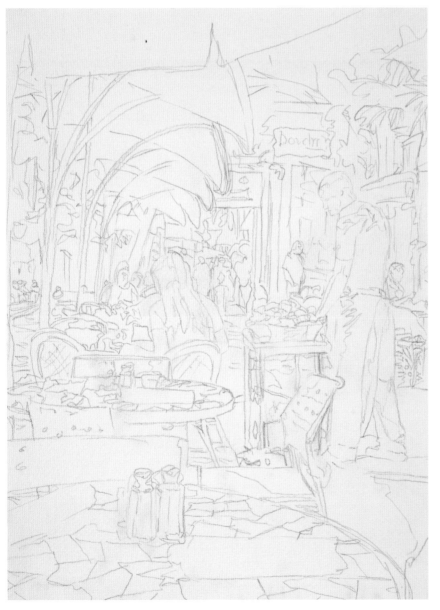

1

Draw Carefully

There is a lot going on in this piece, so you will have to draw a bit of detail in order to be able to save your whites and light areas successfully once you begin to paint. Draw only what you need for that purpose, however. Basic one-point perspective is used here, with a single vanishing point just above and to the left of the center of the paper, past the end of the row of tables. All the perspective lines should converge at that point, but that area definitely will not be the focal point of the composition.

Block in the big shapes first. Next, draw what is nearest to you first and then work back, underlapping as you go. This will cut down on erasing and keep your paper cleaner. Make sure your drawing looks correct before you start painting, while it is still easily fixed.

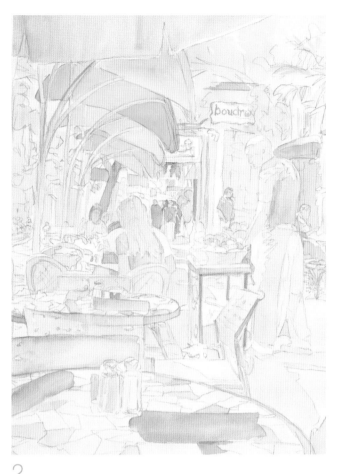

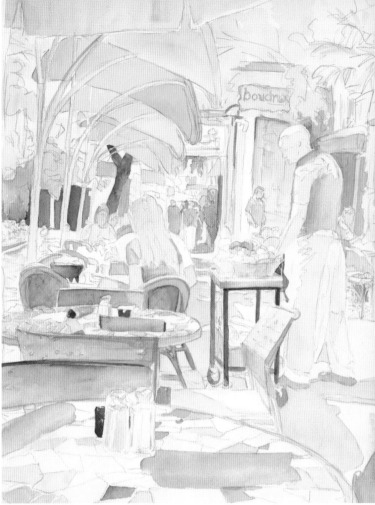

2

Start With Light Washes

Build layers gradually over the entire piece rather than trying to complete one area at a time; it is easier to see the direction in which the painting is going and make any necessary changes. Set the tone for the piece by very lightly blocking in the basic colors. Keep in mind that your main objective right now is to map out patterns of light and shade. Once you decide where your white and lightest areas will be, paint around them with very pale washes to help you save them.

Use Indigo to suggest where your darkest darks will be. Paint in the brown shades, using Burnt Sienna for lighter areas and Burnt Umber for darker ones. Suggest trees and foliage with Olive Green. Paint the reds, mostly on the umbrellas, with washes of Alizarin Crimson. Add a few touches of Lemon Yellow and Ultramarine Light on the table tiles and in the background. Mix Gamboge and Alizarin Crimson to make a pale flesh tone for use on all the figures.

3

Think in Terms of Separating Elements

As you begin to add more color, think about how you will separate various elements from each other, and how you will establish different planes within the scene. If you think in these terms from the start, it will be easier to create the illusion of depth.

Suggest the tiny figures, boat and water in the center-left area. Use Burnt Umber for the tree trunk and the dark area to its left. You want to paint this now so that you can see the umbrella poles. Use a mixture of Olive Green and Ultramarine Light to begin to add a little dimension to the trees. Lay individual washes of Cyan and Ultramarine Light, allowing them to dry in between, on the ground shadows. Paint the chairs with Burnt Sienna. Use Burnt Umber in the background on the right to bring out the figures, table and umbrella.

Mix a near-black using Indigo and Burnt Umber and paint a few of the darks in the foreground. Notice how the edge of the girl's chair defines the edge of the table in front of it. The value change visually separates the two elements and thus creates another layer of visual depth. As you continue to separate overlapping elements throughout the painting you will build many, many layers of depth and end up with a piece that looks very realistic.

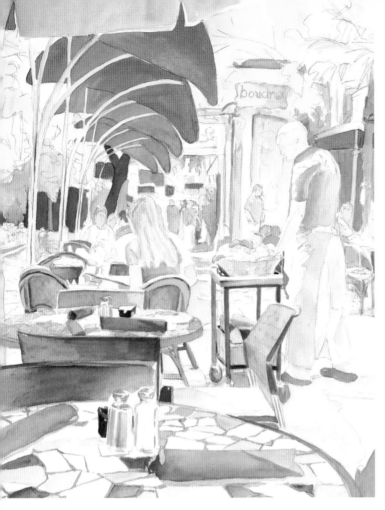

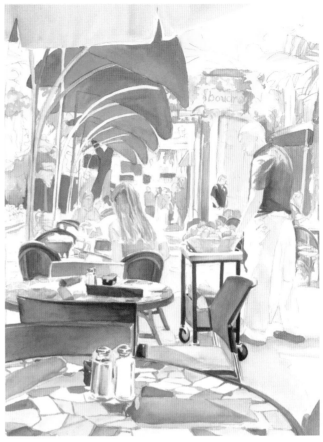

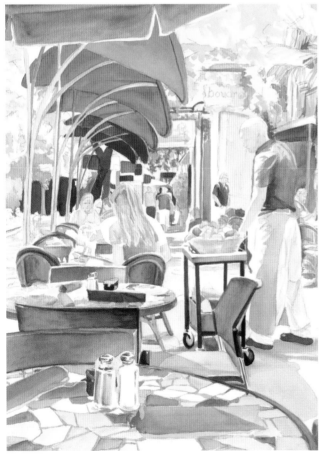

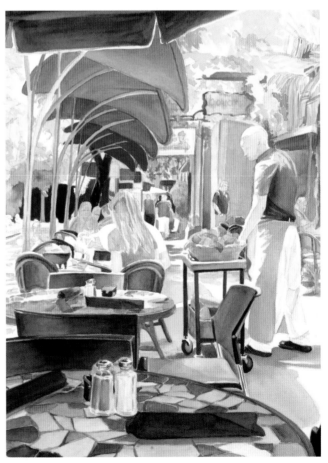

4

Create a Path With Color

Bring vibrant color to the umbrellas with Permanent Red. The trail of color used here helps move the viewer's eye deeper into and around the piece. Every time you use a new color, paint in a few table tiles. Use Burnt Umber to darken the tree and background, and add detail to the chairs, cart and table edges. Mix a deep gray with diluted Indigo and Burnt Umber. Use this mixture to paint the waiter's shoes and shirt, the napkins, the salt and pepper shakers, and to suggest grout between the tiles on the table in the foreground. Use the same mixture with less water to make a black, then paint a few darks on the cart, chairs, napkins and sugar containers. Suggest some detail on the girl's hair with Burnt Umber and Burnt Sienna.

5

Get Dark

Darken most of the chairs, the girl's hair and the table edges with a wash of Burnt Sienna and Gamboge. Use the same color to add more detail to the cart and to paint a few of the umbrella poles. Continue to add different colors to the table tiles, including Cinnabar Green Light and Cobalt Turquoise. Be sure that any color you use for the tiles is repeated elsewhere in the painting. A "foreign" color will draw the eye, and since the table top is not the focal area, you won't want to call that much attention to it.

Add some Permanent Red to the shadow on the ground to suggest a reflection from the umbrellas. With the same black you mixed in step 4, darken the black chairs in the foreground, the shakers, napkins and cart. Paint some folds in the waiter's shirt using the black mixture. Think of the quarter exercise (page 84); leave white and light tones to form the fabric folds, painting only the darker tones. Start to deepen and add detail to the flesh tones. Paint some fruit in the bowl next to the waiter. Use Ultramarine Light on the clothing of a few of the distant figures and to deepen the shadows in the distance. You can use a pale wash of Ultramarine Light on the umbrellas that are the farthest away to tone down the vibrancy of the red and make them recede.

6

Add Detail and Value Contrast

Use mixtures of Olive Green, Ultramarine Light and Gamboge to add more detail to the foliage. Darken and suggest some detail on the blue umbrella at the top with Cyan and Ultramarine Light. With the same blues, darken the shirt of the distant figure, and lightly paint in some folds on the waiter's pants. To paint the waiter's apron, first paint a wash of purple-gray mixed from Ultramarine Light and Permanent Red. Once that is dry, darken the bottom with a light wash of Burnt Umber and Permanent Red.

Mix Magenta and Permanent Red and lay a light wash on the foreground black chair and napkins, and on the shadow area directly under the waiter. Darken the more distant umbrellas with a mixture of Permanent Red and Ultramarine Light. Work on the area where the very distant figures are walking. Darken the darks with Indigo. Wash over the area with a very pale wash of Burnt Umber, leaving the shape of a white umbrella in the distance.

7

Go Deeper and Brighter

Mix a deep brown with Indigo and Burnt Umber and deepen the color in the center-left dark area. Use this color to darken the tree trunk, leaving some of the lighter shade underneath to show some of the detail. Paint a touch of Cerulean Blue in the very distant sky above the tiny figures. Use Ultramarine Light to paint a pale unifying wash over the three most distant figures seated at the tables on the left. They are less important, so you will want to tone them down.

Use a mix of Ultramarine Light and Cyan to deepen the shadow on the ground. Use Burnt Umber and Burnt Sienna to paint the umbrella poles, separating them from one another as you go. Brighten the tables' tiles with additional washes. Paint the wall behind the waiter Burnt Sienna, to help visually pull him forward. Mix a deep black with Burnt Umber and Indigo to paint the waiter's belt and the darks on his shoes. Use the same color to darken the napkins and other black table objects and the black chairs, and for dark touches in the distance. Add more darks to the waiter's shirt. Add a little water to your black mixture to make a dark gray and use it to darken the tile grout and paint shadows under the napkins. Also darken the shakers and the bowl of fruit. Suggest soft-edged detail on the two hanging signs. Deepen the color on the blue umbrella at the top with Indigo and Ultramarine Light. The whites should now appear a little brighter as you continue to darken the piece.

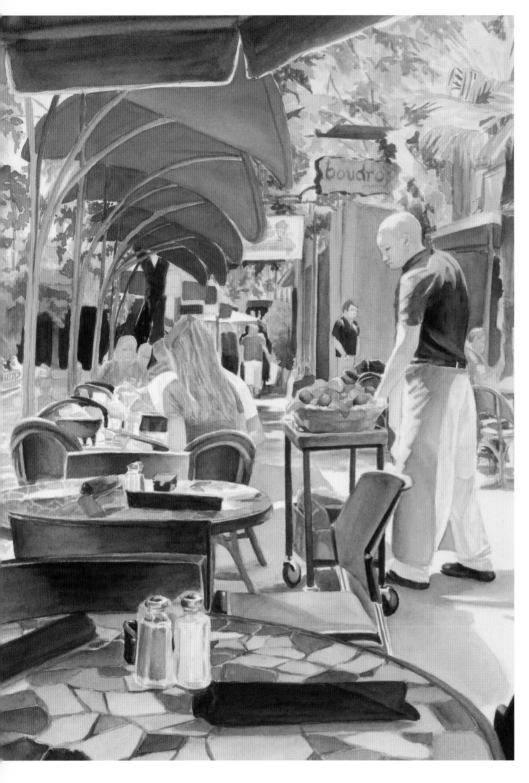

8

Develop the Details

Deepen the color and add detail to the foliage with layers of Gamboge, Olive Green and Ultramarine Light. Use Burnt Umber to suggest a few branches peeking through. Darken the wall behind the waiter with a layer of Burnt Sienna and Ultramarine Light. With the same combination, darken the buildings that are receding in the distance and the second story above the waiter. Suggest a little soft detail on the water and little boat off to the left. Use Ultramarine Light on the wall and shadows to the far right to pop the figures forward. Using your mixed black, add more detail to the waiter's shirt. Darken the clothes on the smaller standing figure and suggest some hair. Paint some detail on the brown chairs, the cart and the girl's hair with Burnt Umber. Darken and add detail to the waiter's apron with Ultramarine Light and Burnt Umber. Suggest some features on the waiter's face using Burnt Sienna.

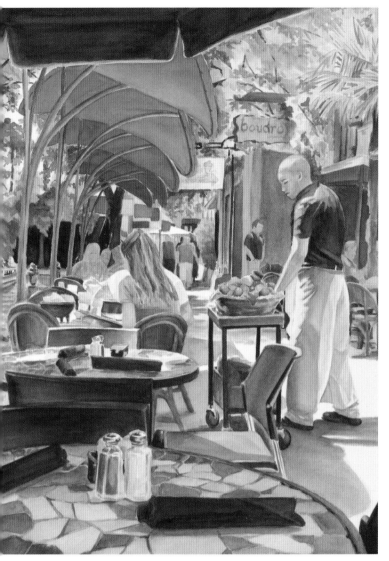

9

Call Attention to Some Areas, Soften Others

Now you will add more detail in some areas, and soften or push back in other areas. Add more Olive Green and Gamboge to the foliage and darken the branches with Burnt Umber. Paint touches of color to suggest people on the boat, and darken the water with Ultramarine Light. Use Burnt Umber to paint the chain railing. Now add a light unifying wash of Ultramarine Light over the three seated figures, the colored tiles on the tables, and the entire area where the figures are seated behind the waiter on the right. This makes these areas less prominent, allowing the focus to be on the waiter, where you want it.

Use Indigo to really darken the umbrella at the top, the waiter's shirt, the napkins and the shadow on the black chair. Darken the shadows on the ground, especially in the distance and directly under the waiter, using washes of Cyan and Indigo. Paint a pale unifying wash over the very distant area using Ultramarine Light. Add detail to the girl's hair with Burnt Umber, and darken her shirt with Olive Green and Ultramarine Light. Mix a taupe color with Ultramarine Light and Burnt Sienna and darken the waiter's apron and add folds to his pants. Paint a wash of Ultramarine Light over the wall behind the waiter. Add darker tones and more dimension to the skin on the waiter and the two figures he is serving, using Gamboge mixed with Alizarin Crimson. The other figures are less important and don't require any more attention.

10

Add Finishing Touches *(next page)*

Just a few more touches will really strengthen your focal point. Add a few more deep greens, using Olive Green and Ultramarine Light, above the waiter to help push this area back. Add a little Permanent Red to the ground shadow under the umbrellas to add more interest to this area. Lay another unifying wash of Ultramarine Light over the entire table in the foreground, even going lightly over the napkins and shakers. Wash over the second table as well, except for the white highlighted spots. You have now toned down the contrast, muted the color, and softened the edges in this area and pulled the viewer's eye back to the waiter. Use a final deep wash of Burnt Sienna to really darken the wall behind the waiter and make him truly pop forward.

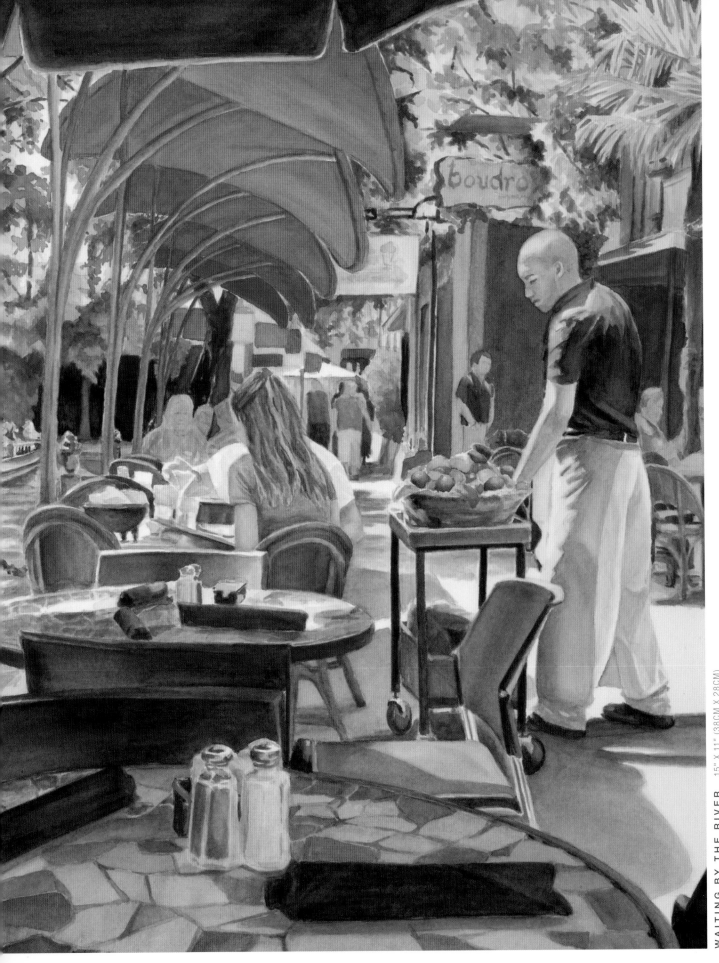

Index

The best in watercolor instruction is from North Light Books!

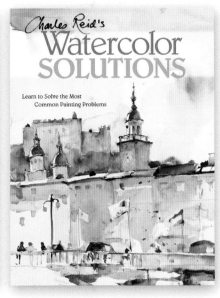

Discover a multitude of ways to energize your artwork with tantalizing texture, juicy color and a fresh spirit of adventure! Through a series of step-by-step demonstrations, this book presents out-of-the-ordinary techniques for creating a multitude of surface qualities and textures. As you scatter different types of salt, pour paint, scrape watercolor pencils and more, you'll experience a surge of artistic spontaneity while creating expressive and personal paintings.

Splash 10: Passionate Brushstrokes, the latest volume in North Light's popular Best of Watercolor Series, is dedicated to discovering how today's artists create great watercolors, and what motivates them to be creative, work in this amazing medium, and portray the subjects they love. This brilliant collection of over 140 works also provides insightful firsthand commentary and masterful tips on style and technique.

Charles Reid is admired around the world for his loose, direct and expressive style of painting. His use of beautiful, clean color and light creates a look of spontaneity that immediately pulls you in. In this book, you'll find solutions to all your watercolor woes. Charles shares his best advice, from the fundamentals of selecting paper and arranging your palette, to composing you figure painting and capturing the spirit of a place.

ISBN 13: 978-1-60061-028-8
ISBN 10: 1-60061-028-5
HARDCOVER, 144 PGS
BOOK # Z1315

ISBN 13: 978-1-58180-971-8
ISBN 10: 1-58180-971-9
HARDCOVER, 144 PGS
BOOK # Z0757

ISBN 13: 978-1-58180-991-6
ISBN 10: 1-58180-991-3
HARDCOVER, 128 PGS
BOOK # Z0938

These and other fine North Light titles are available at your local fine art retailer, bookstore or online suppliers or visit our website at www.artistsnetwork.com.